LOCATION FILMING IN
LONG BEACH

LOCATION FILMING IN
LONG BEACH

TIM GROBATY

THE
History
PRESS

Published by The History Press
Charleston, SC 29403
www.historypress.net

Copyright © 2012 by Tim Grobaty
All rights reserved

Unless otherwise noted, images appear from promotional materials.

First published 2012

Manufactured in the United States

ISBN 978.1.60949.740.8

Library of Congress CIP data applied for.

CONTENTS

PREFACE

I have been covering Hollywood location filming in Long Beach since the dawn of motion pictures. Or, to put a finer date to it, since about 1997 when Jack Nicholson and Helen Hunt were working on the movie *As Good As It Gets*, cavorting around the old Windrose Restaurant, where my wife and I proposed to one another back in 1975.

The actors, who would both win best-acting awards for their work in that film, were also seen down at the Seal Beach Pier and other locations in and around Long Beach. I wrote about it, and my editor at the time, Carolyn Ruskiewicz, suggested, in the way that bosses can "suggest" things, that I write about location shooting every week.

I balked, in the way that writers can "balk" at things when they sense extra work looming. "I can't do this every week," I whined. "There's not that much filming going on."

Well, there was, and is. Each week, I easily filled an empty spot in the paper with news about who was in town from Hollywood and what they were up to.

Many of those columns are in this book, as is the most complete listing of feature films made in Long Beach that I could compile. Is it encyclopedic? I'm going to go ahead and say, with all mock humility, yes. Is it absolutely complete? I have to say no. At some point, I had to cut out some pictures that you've never heard of because they're so small or so bad they can't even make the cut for so-bad-it's-good cult classics. And some, I'm guessing, I just missed somehow. But if there's a more thorough list of what films were made

in Long Beach and where they were filmed in town, I wish I'd known about it before I took on the task.

The incredible and invaluable Internet Movie Database (IMDb.com) does have a lengthy list of titles shot in town, but it rarely mentions where, exactly, the filming took place. The city's online listing is wildly incomplete, and if the film office has a more sprawling list somewhere, it wasn't handed over to me with a nice ribbon tied around it.

I used personal experiences and the *Press-Telegram* archives when I could. In other instances I depended on various websites, the most valuable of which is Gary Wayne's Seeing-Stars.com. Wayne and I have been trading location spots for several years, though he is the master of tracking places down. If you're a film fanatic, or just fan, visit his site. It's pretty brilliant.

John Robinson, who owns and operates Long Beach Locations (www. filmlb.com) and formerly worked with the city's film department, is the most indispensable and reliable person when it comes to tracking down what's going on in Long Beach filming. He's been "our man" in Hollywood for more than a decade, and some of his fine photography is scattered throughout this book (he still hasn't got a movie job for my house, though).

Another fine photographer whose work appears in the book is my longtime friend Thom Wasper, who brings a fearless, mad-dog approach to his work. I've often scampered behind him like a running back following his blocker into sets and locations I shouldn't have been allowed in, and he has wrangled some titles for me from the most secretive sites.

Long Beach librarian, researcher and author Claudine Burnett has, as is always the case, been a tremendous and reliable source of some of the facts in this book, especially regarding the Balboa years. There are some history writers in this town who use her research shamelessly (she is remarkably free with it) without giving her credit. I hope to never forget or neglect to mention the work she has done in archiving and preserving the city's history in every aspect.

Also of great use in the Balboa years is Cal State Long Beach's comprehensive Balboa Research Archives, whose advisory board includes Burnett and author Jean-Jacques Jura. Jura and Rodney Norman Bardin II authored the excellent *Balboa Films: A History & Filmography of the Silent Film Studio* (McFarland, 1999).

For all that, in the end, mistakes and omissions are all mine.

My former boss and now sidekick and co-bickerer Rich Archbold has my everlasting thanks for his eternal support and encouragement, and I'm similarly proud and honored to know and to work, or to have worked, with

so many people who keep writing and otherwise working to keep journalism alive. That's too many names to mention, plus I'm running out of space, which I can't allow to happen before giving thanks to my beloved wife, Jane, and our two beautiful children, Ray and Hannah. This book is dedicated to all of you.

Chapter 1
BALBOA FILMS

Even before filmmaking, things were in place for the little seaside town of Long Beach to become a world-class moviemaking capital. Theaters in downtown, especially along the Pike amusement zone, were regularly packed with entertainment-seekers enjoying legitimate theater and vaudeville acts.

Before he went on to wealth and fame in New York (and returned later to Long Beach for more), Roscoe "Fatty" Arbuckle sang and performed in comedy acts at the theaters, including the Byde-A-Wyle at 336 The Pike. At that same theater, in 1908, he would marry a young dancer, Minta Durfee, who would co-star with him in some of his films.

On June 22, 1900, while the moving picture was still very much in its novelty stage, not quite threatening to kick vaudeville and stage performances out of the nation's theaters, Long Beach's largest assembly hall, the old Tabernacle, built at the northeast corner of Third Street and Locust Avenue, hosted a showing of a Thomas Edison picture, bringing what would later be termed "Hollywood" to Long Beach. Had things worked out a little differently, in fact, Long Beach today would be synonymous with the art and industry of filmmaking.

In 1910, a group of Los Angeles and Long Beach businessmen, headed by T.L. Howland, of Long Beach, formed the California Motion Picture Manufacturing Company. Howland, who had financial ties with the Bijou Theater in Long Beach, told the *Long Beach Press* that demand for new motion pictures was far outweighing the supply. There were, in fact, already thousands of movie houses in the country (thanks to the easy conversion of

vaudeville theaters into movie theaters), and the country's audiences were devouring the relatively meager output of the studios.

Did the new company have ambitious plans? It did. In their comprehensive *Balboa Films: A History & Filmography of the Silent Film Studio*, authors Jean-Jacques Jura and Rodney Norman Bardin II found the company's articles of incorporation, which state as the business's plans:

> *To engage in and carry on the business of manufacturing moving or motion pictures. To engage in the art and manufacture and sale of photographic motion picture films for the purposes of advertising, instruction, amusement, and such other profitable uses and purposes, as the Board of directors may direct.*

Fair enough. But then it adds this:

> *To conduct amusement enterprises in all the branches pertaining thereto and thereof; consisting of summer gardens, parks, hotels, dance halls, bathing beaches, roof gardens, theaters, nickelodeons, and to run steamboats and other boats for excursion and other purposes; to operate any plays, operas, songs, musical or dramatical performances and other things relating thereto which may be used for amusements of persons in public and private places, and to conduct amusement enterprises of all kinds; to buy, purchase, lease, option, or otherwise acquire, own, exchange, sell or otherwise dispose of, mortgage and deal in real estate, lands, or buildings for the erection and establishment of theaters, halls, offices, stores and ware-houses, with suitable plants, engines and machinery for the furtherance of the businesses named herein; to construct, carry out, maintain, improve, manage, work, control or superintend any private mills, factories, ware-houses and other works and conveniences, which may seem directly or indirectly conducive to the objects of the Company, and to contribute to, subsidize or otherwise aid, or take part in such operations.*

It may have been a tad ambitious. At any rate, the company lasted about three years. In the spring of 1913, Herbert Morris Horkheimer, flush with a $7,000 inheritance, bought the company's property on Alamitos Avenue at Sixth Street. Balboa Amusement Producing Company was born, and the new company began making movies like crazy.

The plant, when Balboa acquired it, consisted of one small building and a platform twenty-five by seventy-five feet, which served as a stage. In that sole building were the dressing rooms, offices, carpenter/paint shops and laboratories.

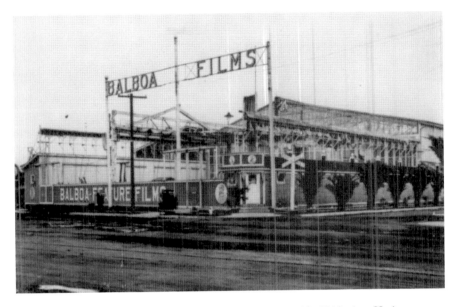

The Balboa Amusement Producing Company was established in 1913 when Herbert Morris Horkheimer bought a small film company on Alamitos Avenue at Sixth Street. *Courtesy of* Press-Telegram *archives.*

The Horkheimers churned profits into growth as Balboa blew up to a mammoth plant of more than twenty buildings, including a glass studio for filming using natural light. There were huge prop departments, including a sprawling *papier-mâché* department for fabricating set designs. While most film studios at the time rented props, including furniture and wardrobes, Balboa amassed a collection of more than 100,000 pieces. A garage big enough to hold twenty cars was built.

The site was equipped with separate buildings for studios, workshops, offices and comfortable quarters for the talent. A massive open stage of eight thousand square feet and an enclosed area of two thousand square feet allowed up to eight film companies to shoot at Balboa at the same time. An additional thirteen acres in Signal Hill was owned by the company for use in westerns. The studio's processing lab turned out twenty thousand feet of negative film in a week and kept the city's—and the nation's—filmgoers happy.

The large, glassed-in studio was built, to a large degree, to lure the by-then-famous Fatty Arbuckle from his home and work in New York and New Jersey. Arbuckle brought to Balboa his Comique Film Corporation, along with such superstars as Buster Keaton and Al St. John.

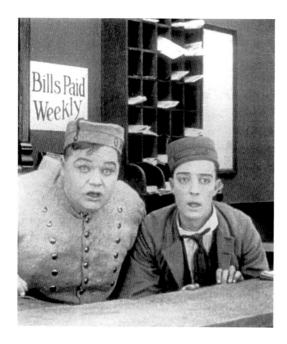

Fatty Arbuckle (left) and Buster Keaton were two of the biggest stars working in Long Beach during the Balboa Studios era. *Courtesy of* Press-Telegram *archives.*

In 1916, a *Picture Play Magazine* reporter asked H.M. Horkheimer if he considered it more advantageous to produce in Long Beach than in Los Angeles.

"Yes, indeed I do," said Horkheimer. "And there are three reasons why I do. We avoid the riffraff, clamoring for work, that haunts the other studios, for one thing. We have the busy and only seaport in this part of the country in San Pedro, not five minutes distant by car, for another. And we have one of the most picturesque and beautiful ocean beaches in the world, for a third."

He could have added that Long Beach was already home to scores of actors, comedians and other performers, as well as stage workers and prop builders, all employed by the vaudeville theaters.

Horkheimer attributed the loyalty of his employees to Balboa's success, as well. "We try to make our people one big family," he said.

He did appear to treat his workers well. In his first Christmas as owner, Horkheimer threw a Christmas Eve dinner-and-dance gala at the opulent Hotel Virginia on Ocean Boulevard. He invited his still moderately sized staff of forty-three actors and actresses, cameramen, directors, scenarists and others, as well as A-list guests, including actress Mary Pickford.

The early and rapid success of Balboa was secured by some savvy decisions made by Horkheimer, including forming distribution alliances with William Fox,

just a year before the Hungarian film producer would open his Fox Studios. Fox handled distribution of Balboa films throughout North and South America, while Horkheimer signed similar contracts for distribution in Europe.

Audiences were still going wild for new product, and the quality of films was improving. That appetite is still going strong in the twenty-first century, with long lines and midnight openings for blockbuster hits. But it's difficult to imagine a *Star Wars* meets *Batman* meets *Twilight* aboard the *Titanic* outdoing the enthusiasm that met the opening days of Balboa's picture *A Will o' the Wisp*, filmed at the studio and on location in the northwest section of Long Beach at a time when it happened to have been inundated by a flood.

The Moving Picture World wrote about the record-breaking box-office success of the film when it opened at Long Beach's Columbia Theater on the Pike's Seaside Avenue in July 1914:

> *Breaking all former records in big box office receipts at the Columbia Theatre in Long Beach, California, the Balboa Amusement Producing Company's four-reel feature film, "A Will o' the Wisp," was shown at the playhouse named last Monday, Tuesday and Wednesday. In the four years since the theater was instituted there never before had been such a great crush of theater-goers, blocking the doors and massing in crowds for several hundred feet from the entrances... During the three afternoons and evenings this week, the services of city firemen and policemen were necessary to hold the throngs in check at the theater doors, and hundreds were turned away daily because the playhouse was not large enough to seat the hosts of eager pleasure seekers. On Tuesday evening several women were hurled to the pavement by the press of the surging crowds and for a time it seems they would be seriously injured, but were rescued by three policemen and carried outside the throng.*

By 1917, Balboa was the city's largest employer, with some 350 regular employees (about a third of them actors), and a key tourist attraction.

Horkheimer's business was booming, with the help of his brother E.D. Horkheimer, who came out to run the financial part of the studio, and he had settled on the four-reeler as the optimum length for a feature film. He told *The Moving Picture World*:

> *For the adequate telling of a good dramatic story on the screen, three reels are too short and five reels too long. So I have decided on four as the happy medium. The average stage play is in four acts. Exhibitors have*

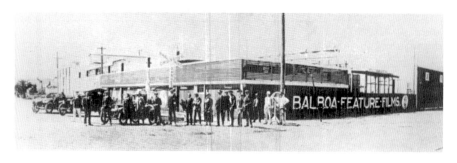

The Great War, the Spanish influenza pandemic and the discovery of oil in nearby Signal Hill all ganged up in ending Balboa Studio's great run. *Courtesy of* Press-Telegram *archives.*

been complaining about five-reel productions, because the most of them are padded to make the length. They want variety on their program. This is possible with a four-reel picture, which requires an hour to project. That allows time for a short comedy, some news pictures and any other novelty like an animated cartoon.

Everything, in short, was going great for Balboa and Long Beach. Then the whole thing tumbled down with the jarring flash of film editor's smash-cut.

There were a number of factors in the studio's demise, any one of them, perhaps, fatal. Among the smaller problems was the fact that distributors and theater operators were growing miffed at the overly prodigious output of Balboa. Balboa's European distributor had begged the studio to slow down production and eventually refused to distribute its films. Also, some studios, such as Fox, were buying theaters to show their own films.

Horkheimer might have weathered those problems, but there was no overcoming a trinity of larger woes.

First were the effects of World War I, or the Great War, as it was called before World War II gave its predecessor a number. The war effort made film stock almost prohibitively expensive. The war, too, obviously had an effect on the theater business in general and in Europe in particular. The industry as a whole went into a slump during the war years between 1914 and 1918, and several major studios worldwide closed.

Second was the influenza pandemic of 1918, which infected more than a quarter of the world's population and resulted in the death of 50 million to 130 million people. In an attempt to prevent its spreading, many public meeting places, including most of the theaters in the country, were closed

for weeks, resulting in a filming industry slump from which it would take a year to recover.

Balboa Studios was on the ropes and already mortally wounded by the time the third factor kicked in: the discovery in 1921 of oil in Signal Hill. And not just a little oil. It turned out to be the richest deposit, in terms of barrels of crude oil per acre, in the world. You think there's money in moviemaking? Forget it, the mad stampede for oil totally trampled the mammoth Balboa Studios as Long Beach was awash in liquid gold. Overnight, the city was transformed from a world-renowned moviemaking city and amusement mecca into a world-renowned oil center as it moved toward the big business of industry and shipping.

The ensuing real-estate rush started gnawing at the edges of Balboa's property, already in receivership, from which it would not recover.

The Balboa Amusement Producing Company finally ceased to exist even in its physical form in January 1925, when its magnificent glassed-in soundstage and other buildings were demolished.

H.M. Horkheimer died, fittingly or ironically, in Hollywood in 1962. His brother died in 1966 in Beverly Hills.

Chapter 2

WHY LONG BEACH?

In the course of our day job as a columnist in Long Beach, we have seen a bus full of people explode. They were fake people—mannequins—so it could've been worse.

We have seen a man jump off the roof of a twelve-story building. It was a real man, so it would've been horrible if he hadn't landed in a giant, billowy air bag and then strolled over to a nearby table to grab a donut and a cup of coffee.

We have seen giant robots—one was Ironman, we're pretty sure—duking it out on the freeway. Pretty much an everyday occurrence downtown, so who hasn't seen that?

Once, we saw this guy with a flamethrower strolling pretty casually down First Street in the East Village setting cars and businesses and trees on fire until a couple of cops came along. One, the black cop who was clearly too old for this kind of thing, took off his pants to distract the flame-throwing guy, while the other cop shot the gas tank that was strapped to the flame-throwing guy's back, turning him into a human torpedo and launching him across First Street into an oil tanker that was parked at a Union 76 station at Elm Street. Flame-throwing guy hit the tanker, and the whole mess exploded. Not sure what that was all about.

You walk around Long Beach enough and you begin to notice that it's a pretty weird place. Where else do you see monkeys building a spaceship in a backyard or Mr. T driving a tank through a house, firing Snickers bars out of a Gatling gun? You think every town has a topless young woman throwing herself off a building as tall as Long Beach's thirty-two-floor International Tower?

Why Long Beach?

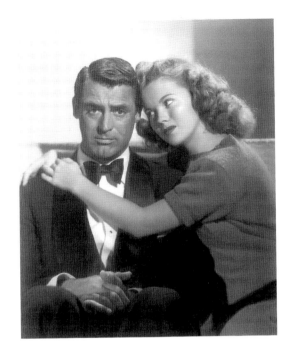

The 1947 feature *The Bachelor and the Bobby-Soxer*, starring Cary Grant and Myrna Loy, was one of the many titles filmed at Long Beach Airport.

Long Beach is one part regular town full of regular people, and it's another part fabrication and fantasy. A city council and film directors run it, seemingly in equal parts.

Filmers are here virtually every day making anything from a car commercial to a box office-demolishing action-packed feature film. And it's been that way pretty much since the opening days of the 1900s, when Balboa Studios was one of the biggest filmmakers in the world, operating out of a huge compound of buildings and soundstages on all four corners of Sixth Street and Alamitos Avenue.

When oil was discovered on Signal Hill and roughnecks and roustabouts began outnumbering gaffers and key grips, filming all but disappeared from Long Beach, save for some location work done at the Pike.

It was spotty during the 1930s and fairly sparse during the 1940s, though Long Beach Airport started getting some screen work, in such films as *The Bachelor and the Bobby-Soxer*. Things picked up a bit in the 1960s, particularly in television, but also with the 1963 big-screen blockbuster *It's a Mad, Mad, Mad, Mad World*, which used dozens of locations in Long Beach.

But it was in the 1980s when Long Beach quit waiting tables and got serious about its life as a Hollywood actor.

We are tempted to say it all began when crews for the making of 1985's *Perfect* descended (or ascended, more properly) on the second-floor features department of the *Press-Telegram* at Sixth Street and Pine Avenue. The crew spent several days setting up the shot, the star of which was to be our desk, with Travolta sitting behind it, playing the role of a loser obituary writer before that writer became a big shot for *Rolling Stone* magazine.

Crews monkeyed around for a couple of days setting up. The office was decorated with Christmas cards for the scene, and we watched for a couple of hours as an electrician and a plumber argued over whose job it was to turn off the water cooler that was next to our desk. Seems the humming from the cooler was making too much noise for the director.

"I've got it," said the plumber.

"Hell you will," said the electrician.

"It's a plumbing device," shouted the plumber.

"It's an electrical appliance," screamed the electrician.

"Will someone please turn it off?" wailed the exasperated director.

"Tell him I should do it," they both replied, pointing at one another.

"Cold water comes out of it, seems like it should be the plumber's job," said the director.

"Cold water comes out because of electricity," said the electrician. "Plus, it's the electrical motor that's making the noise."

This is why pictures cost $100 million to make.

Eventually, it got turned off (by the electrician—hard to argue with the electric-motor argument), and a bit later, the talent showed up.

"I'm going to make your desk famous," Travolta said to us.

"It already is," we replied.

At any rate, the movie tanked. Don't blame the furniture.

The city began, in the 1980s, to take filming seriously, recognizing that it brings a mountain of revenue, if not a little prestige, to town.

By the mid-1990s, probably the busiest boom years for major feature filming in Long Beach, the *Motion Picture Association of America on the Economic Impact of the Entertainment Industry on California* reckoned that production work in Long Beach was bringing more than $45 million into Long Beach each year.

Maybe. They do spend a lot. When *Lethal Weapon 4* was blowing up half of East Village, we talked to local merchants who were ecstatic with the money being spent—everyone from glass-store owners to florists and coffee house operators. JoAnn Burns, then head of Long Beach's film office, said that the film spent a bit more than a $1.5 million in town. More recently, Tasha Day,

the current boss of filming in town, told the *Long Beach Business Journal* in 2012 that the film industry has an annual economic impact of $1.3 million.

The film permit fee charged by Long Beach is almost nothing to Hollywood: $525 a day. Crafts services will spend that much on bean dip during a production. But it adds up. There's a bothersome $368 for the filing application. The production pays Day and her staff $105 a day for a site visit; $78 per hour for standby.

Then, the number of police and fire personnel required for a film depends on a lot of things: how many streets need to be closed, the overall scope of the project and the potential dangers involved with various explosions, car crashes, fires and other mayhem that audiences demand these days

The production is charged $91.90 per hour for a Long Beach Police Department sergeant, plus whatever equipment is required (a car, for instance, goes for $40); a less-decorated police officer rents out for $69.85 an hour, plus equipment. A fire department spot check is $100 a throw, and there's plenty more. And after that, the city charges an administrative fee of 7.5 percent of the total fee, and a city services coordination fee of 15 percent of the total. At this point, the city is practically making Clooney dollars for its role.

The inevitable question is this: Why Long Beach?

Long Beach likes to think it's because of its pretty face and its adroit ability in the art of acting. And that is, in fact, part of it. Long Beach not only has a pretty face—its bays and beaches, its streamlined speedways that dart between elegant glassy palaces—but it also has a lot of faces. It's done Miami, of course, but it's also done New York, Chicago and Anytown, USA.

It's done the distant past and the imagined future. Its airport alone has played fields as far-flung as Shanghai and Calcutta.

The Port of Long Beach's acting career goes back to Charlie Chaplin's *Modern Times*, and the *Queen Mary* has taken on scores of jobs, most since the ship's been in Long Beach, but the *Queen* even worked back in the days when she sailed.

And the town does have its acting chops. It can do comedy, horror, action, drama and romance—often simultaneously—without getting all prima donna about it. It doesn't sulk in its trailer. It gets out, does the job, and moves to the next project.

Just as important as its looks, ability and diversity of locations is Long Beach's geographical location itself. It falls snugly within Hollywood's thirty-mile zone (also called TMZ, for Thirty Mile Zone). Unions relating to filming use this zone to determine their workers' pay scale. Tiptoe out of the

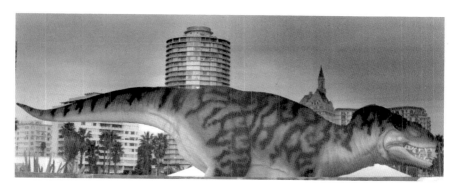

Dinosaurs roaming the coast of Long Beach, like this one from *The Last Action Hero*, are just part of the scenery in the film-friendly town. *Courtesy of* Press-Telegram *archives*.

zone and wages skyrocket. The studio zone, as it's also called, radiates from the intersection of Beverly and La Cienega boulevards – about where you'll find the Beverly Center today—in Los Angeles.

The diversity of looks is apparent. Of course, there are all the aquatic locations, with their attendant palm trees, allowing Long Beach to do a spot-on Miami or Florida in general. But there's also the stately mansions of Los Cerritos/Country Club Drive, the sinister and blue-collar Port, the small-town look of East Village's First Street, the swanky Paul Tay ranch-style homes of Park Estate and the mid-century Cliff May rancho homes in the Plaza. There are few neighborhoods in town that have escaped the lens of Hollywood.

To top it all off, there's the city's amiability to filming. Beginning with JoAnn Burns in the '80s and continuing with Dave Ashman and, now, Tasha Day, film permits issued by the city have grown from fewer than fifty a year to more than five hundred now (that includes still photography and student films).

And, while filmmakers are turning to other locations throughout the United States and Canada, where tax breaks and other incentives are used to lure the lucrative and glamorous business of Hollywood, Long Beach will surely be a film capital as long as the city keeps its good looks and talent.

Chapter 3

IS YOUR HOUSE A
MOVIE HOUSE?

Each year, show biz spends millions of dollars in Long Beach in location money alone, and what do you get? A giant cable bill and the chance to spend dozens of dollars each time you go to a movie theater to see your hometown on the big screen.

How can you tap into the lucrative locations racket? Well, first you need to own some property—we know, it's a big catch, but you knew going in that it takes money to make money.

Then, unless your property is so absolutely cool that it sells itself to Hollywood (If you own the *Queen Mary*, for instance, or the Vincent Thomas Bridge, you can quit reading now. Go. Enjoy yourself.), you'll likely want to use a representative to deal with Hollywood in terms of first getting your home or business in front of showbiz's location scouts, and then to grapple with the permits, the pratfalls lurking in fine print and other hassles.

You don't need a palace. You've seen ugly homes on the screen before. If you have a frumpy house, just think of Danny DeVito. Gold. A house just like ours, only a few blocks away, was used for a Jack in the Box commercial. It had a rocket and monkeys in it. A rocket and monkeys! Our house is still bitter about not snagging that role.

You can cruise the Web for location services to find one specializing in your area. If you're in Long Beach or nearby, Long Beach Locations (www.filmlb.com) would be the best place to start.

The company's president, John Robinson, put in more than a dozen years working with Hollywood for the city of Long Beach, setting up location

shoots and otherwise dealing with the business of filming in town, before he set out to start his own firm.

Today, he represents hundreds of local sites, ranging from downtown lofts to Country Club Drive mansions, burger stands and taverns to hotels and churches. His list of locations includes bowling alleys, hospitals, jet flight simulators, butcher shops and schools—and block after block of houses.

He's put homes and shops in commercials for Miller Beer, Mitsubishi, Kraft Foods and T.J. Maxx; in TV series like *Ally McBeal, Joan of Arcadia* and *The Agency*; and in such feature films as *Donnie Darko, American Pie 2* and *Red Dragon*. In a year, by his reckoning, he brings in more than $700,000 worth of film-related revenue to Long Beach.

And there's plenty more to come.

"Long Beach gets so much work, and it's starting to appear as more and more different places," says Robinson, who's almost always on the local roads, scoping new locations or helping set up shoots at his current sites.

"When people used to ask me what kinds of houses I was looking for, I'd tell them that what Hollywood wants the most is an Anywhere, USA, type of house," he says.

"Filmers wanted houses that a person in Iowa would think could be in their town. The plainer the better. And palm trees were definitely a deal breaker. There were so many properties that were no good because palm trees were in the background."

Now, palm trees are cool again, says Robinson, thanks to Hollywood's decision that Long Beach can easily pass for Miami, Miami Beach, Biscayne Bay and even Key West. The city has played Floridian roles in such recent projects as TV's *CSI: Miami, Nip/Tuck* and the canceled *Karen Sisco* and in such feature films as *Bad Santa, Blow, Jerry Maguire* and *The Odd Couple 2*. In his leaner days, Robinson listed just about any house he could on his website, but now he's got the site pretty well populated with more than two hundred homes (along with more than three hundred commercial sites). Even so, he'll still list your house.

OK, you're in. Now what?

It's like fishin'. Your house is the bait. The website is the hook (Robinson says it gets hundreds of hits a day—nibbles, to maintain the metaphor), and Hollywood is the big trophy fish.

"A location scout will call me and say he's interested in looking at your house," explains Robinson. "Then, the location scout or manager will come out and take pictures of your house inside and out and take them and show them to the film's director. If it makes that cut, the director

Is Your House A Movie House?

Crews shoot a scene for *Joan of Arcadia* at a Long Beach residence. You should know what you're getting into if you're planning on letting Hollywood borrow your house. *John Robinson/Long Beach Locations.*

and the production designer and maybe others will come down to your house and look it over in person. They'll look at it again. And again. And again. They'll see how it looks at different times of the day, look at the neighborhood, talk to the neighbors."

Robinson works with the property owner throughout the process, and he helps smooth out any problems and, finally, negotiate a price. "Basically, I prepare the homeowner for the army or circus that's about to fall upon their house," he says.

The money isn't bad, especially considering your house doesn't have to do much of an acting stretch. No working at developing an Eastern European accent or putting on sixty pounds for a role. It just has to sit there and look pretty—kind of like what Cameron Diaz does.

Typically, for a TV show or feature film, you'll score $3,000 to $4,000 a day—maybe more if you're a hardballer.

Contributing factors are whether the film company is shooting exteriors or interiors, whether they're going to be there all night and day, whether you

are being displaced and thrown into a hotel (never let it on that a hotel, no matter how luxurious, is anything but a major inconvenience and disruption of your normally idyllic life's routine) and whether you were able to feed your family during the process.

Your basic three-bedroom, two-bath 1950s-era house isn't at the top of most filmers' wish lists.

But, says Robinson, the Anytown, USA, house is still in demand.

"If you've got a house in a good-looking neighborhood, preferably a two-story home that looks like it could've been used in *Leave It to Beaver*, give me a call," he says.

There are dozens of things you need to think about before jumping all over that $2,000–$3,000 paycheck for doing nothing.

The California Film Commission offers a free handbook for people considering allowing Hollywood to use their property. Among the countless considerations—and how unusual is this in Southern California—is parking.

Southern California locals are used to seeing feature film encampments in certain parts of the city, where there are sometimes large lots available. Certain locations are easy for Hollywood: the beaches' parking lots in the off-season; stadiums, schools (when school's out); and office buildings with lengthy stretches of frontage roads.

But can your cozy, quiet neighborhood (and your cranky, not-so-quiet neighbors) cope with a major feature film? Let us answer for our own little block: No.

Here's what the California Film Commission says you can expect, just in terms of vehicles. Needing to be parked fairly close to your house will be:
- thirty-five-foot, five or ten-ton electrical truck (contains all lighting equipment)
- thirty-five-foot grip truck (contains other equipment)
- sixty-foot, ten-ton production truck (may include generators at rear of tractor)
- twenty-foot camera van (camera equipment)

Space permitting, this equipment also needs to be parked as close as possible to the location:
- thirty-foot, five-ton set dresser's truck (contains props, flats, greenery)
- thirty-foot, five-ton special effects truck (if required, contains material/props for stunts, special effects)
- thirty-foot crane (if needed, a large crane on wheels)

Is Your House A Movie House?

Parked nearby:
- sixty-five-foot dressing room/toilet unit (commonly called a "honey-wagon")
- thirty-foot pickup truck with wardrobe trailer
- thirty-foot catering truck
- Motor homes eight- by twenty-five feet (two or more), for actors or director
- fifteen-foot maxi-van (for shuttling crew, cast)
- Production cars—two or three vans (for errands, runs to studio).

Don't know about you, but our neighbors inundate the city council with complaints when a guy parks a motorhome on the street.

There are plenty of other resources for you, including how to lure Hollywood into using your business or community in films, plus access to other locations scouts and services at www.film.ca.gov.

Finally, it's always good to talk to someone who's been there. Andy Crawford of Long Beach, who has worked in film crews as a dolly grip for more than fourteen years, told us that having your home used as a film set can be lucrative, but he also mentioned some caveats.

First, something that often gets left out of negotiations are neighbors. A crew filming a feature can bring ten or more forty-foot trailers and a dozen more smaller cast and makeup trailers. If there's already a parking problem in your area, it will be severely increased for the length of the filming. It's quite possible that when your neighbors get home from work, they won't even be allowed to drive on their own street.

Second, people need to be aware that when a company shoots in their house, things can get badly damaged. Paint, floors, etc., will all be restored to their original condition or better, but irreplaceable things get broken easily when there are sixty tired people crammed into your house.

Third, if a company really wants to use your house, they'll tell you anything you want to hear. They'll tell you they'll be done by ten when they know they'll be there till three. They'll tell you that no one will ever go into your special room (until they need to). They'll tell you that there won't be an army of people using your bathroom, and so forth.

In short, while being very lucrative, renting to a production company carries certain negative possibilities that should be considered. I've seen enough people angry about how they were treated to believe that these are things that few first-timers think of.

Chapter 4

FEATURE FILMS MADE IN LONG BEACH

ABBOTT & COSTELLO IN HOLLYWOOD (1945)

Bud Abbott, Lou Costello. During a madcap chase scene, Lou Abbott gets a wild ride on the Cyclone Race at the Pike amusement park.

ACTION JACKSON (1988)

Carl Weathers, Craig T. Nelson. Moviemakers built a plywood forty-foot yacht and blew it up in a huge explosion in Queensway Bay. The Long Beach Police Department got calls from nearby residents who were alarmed by the explosion.

AGENT RED (2000)

Dolph Lundgren, Meilani Paul.

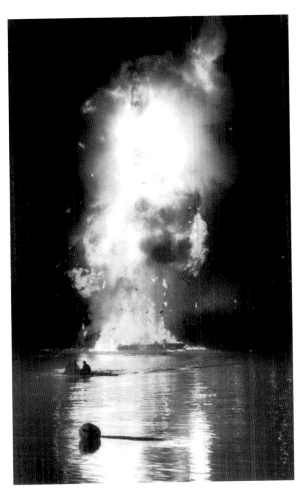

Left: Explosives and sixty gallons of gasoline were used to blow up a replica of a forty-foot motor yacht at the mouth of the L.A. River for *Action Jackson*. *Courtesy of Press-Telegram*.

Below: A crash scene was set up by crews on the Terminal Island Freeway between Anaheim and Willow streets for the film *Air America*. *Courtesy of Press-Telegram*.

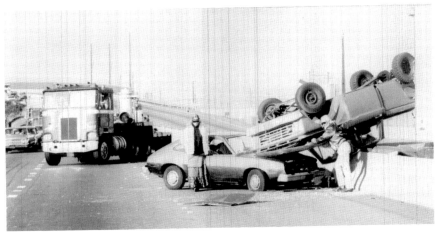

AI: Artificial Intelligence (2001)

Haley Joel Osment, Jude Law. Director Steven Spielberg made use of the mammoth soundstage that was built inside the Spruce Goose Dome near the *Queen Mary*, later called the Queen Mary Dome. Built in 1983, to house Howard Hughes's famous plane, it's been used as a makeshift film studio since the Goose was whisked off to McMinnville, Oregon. At 415 feet in diameter and 100 feet high, it's the largest geodesic dome in the world.

Air America (1990)

Mel Gibson, Robert Downey Jr. One of the least exciting roles in Hollywood is that of an extra, and the job was made even less exciting for the five hundred or so people paid five dollars an hour to sit in traffic in four hundred pre-1972 cars for the filming of a traffic jam on the Terminal Island Freeway at Anaheim Street following the orchestrated crash of a semi rig and the resulting jam, as reported by Downey from a news chopper overhead. Another scene for the film was shot at Berth 55 Seafood Deli at 555 Pico Avenue at the harbor.

Alien: Resurrection (1997)

Sigourney Weaver, Winona Ryder.

All About Steve (2009)

Sandra Bullock, Bradley Cooper. Crossword puzzler Mary Horowitz (Bullock) met with her editor in the *Press-Telegram* Building at 604 Pine Avenue. As long as filmers were in the neighborhood, they shot a scene of Bullock walking past an apartment building a block away at 110 West Sixth Street.

AMERICAN BEAUTY (1999)

Kevin Spacey, Annette Bening and Thora Birch. Classroom and high-school hallway scenes involving the film's young stars Thora Birch and Mena Suvari were filmed at Long Beach Polytechnic High School, Exterior high-school shots were done at South Torrance High School in Torrance. Additional scenes were filmed at First Methodist Church, 507 Pacific Avenue.

AMERICAN DREAMER (1984)

JoBeth Williams, Tom Conti. Filmed largely on location in Paris, one of the best scenes, according to Pat Bulseco, a resident of the frequently filmed Los Cerritos, or Country Club, section of town, a great scene takes place at the so-called Ferris Bueller House on Country Club Drive, in which Williams's character lives with her husband. "The scene takes place on the house's driveway," wrote Bulseco in an email. "The husband pulls up with all his golfing buddies and invites them in—'the little woman won't mind'—and she walks out, says, 'I'm going to Paris,' and gets in a taxi!"

AMERICAN PIE (1999)

Jason Biggs, Chris Klein, Thomas Ian Nicholas. The *American* trilogy (including *American Pie 2* and *American Wedding*) made extensive use of the city's upscale Los Cerritos neighborhood. The main Pie house, where Jim (Jason Biggs) lived, is a stately house at 4153 Cedar Avenue. East Great Falls High School, where the Pie kids endured a semblance of education, was played by two Long Beach high schools. Exterior scenes were filmed at Poly High, while classrooms, hallways and, most notably, a bathroom, were filmed at Millikan High School. Millikan was also used for scenes of football and lacrosse games.

AMERICAN PIE 2 (2001)

Jason Biggs, Seann William Scott, Shannon Elizabeth. A few doors down the street from Jim's house at 4153 Cedar Avenue is the home where Michelle (Alyson Hannigan), Jim's "love coach," lived, at 3925 Cedar. An old house that was being painted yellow in the film is at 4165 Country Club Drive. When the guys go on a road trip to "Green Harbor, Michigan," and go cruising for girls in town, they're shown crossing a bridge, which is the Davies Bridge, connecting Belmont Shore and Naples. (The Main Street they visit in Grand Harbor is filmed on Main Street in Seal Beach; you can see Walt's Wharf and O'Malley's restaurants, as well as the Seal Beach Pier). The kids are in college now, with scenes filmed at Cal State Long Beach.

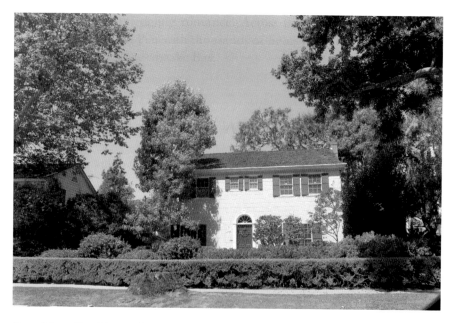

One of Long Beach's most famous residences is the *American Pie* house on Country Club Drive in Los Cerritos. *Hannah Grobaty.*

AMERICAN WEDDING (2003)

Jason Biggs, Alyson Hannigan and Seann William Scott. Jim's house is again featured at 4153 Cedar Avenue. The florist's (Kate Hendrickson) house can be seen at 4107 Cedar Avenue in the same neighborhood. A scene featuring Steve Stiffler (Seann William Scott) teaching Jim how to dance was filmed at St. Anthony High School, 620 Olive Avenue.

AMISTAD (1997)

Djimon Hounsou, Matthew McConaughey, Anthony Hopkins. Steven Spielberg directed this true-life slave-trader/courtroom epic starring Anthony Hopkins as John Quincy Adams. Spielberg used the then-Long Beach-based tall ship *The Californian* in the title role, with scenes shot off the local coast.

ANCHORMAN: THE LEGEND OF RON BURGUNDY (2004)

Will Ferrell, Christina Applegate, Steve Carell: The comedy is set in San Diego, but Long Beach took on the role of that city for much of the movie. After shooting some scenes in real-life San Diego to establish the setting, filmmakers moved to Long Beach to stage an early scene in which a Channel 4 news chopper (shown hovering over, again, the real San Diego) lands on Ocean Boulevard and Atlantic Avenue in downtown Long Beach. In the background, Long Beachers (and students of the opening scene in *Lethal Weapon*) will recognize their city's iconic International Tower building. The tower was renamed the Esquire Hotel for the film. And viewers will also note that Atlantic Avenue has been changed to Main Street. Another early scene shows Ferrell and new co-worker Applegate encountering a rival news crew in a park. That's Shoreline Aquatic Park on the waterfront in downtown Long Beach. Finally, in a scene where biker Jack Black tosses Ron's dog Baxter off a bridge, the pooch is being tossed from the Queen's Way Bridge.

ANGELS & DEMONS (2009)

Tom Hanks, Ewan McGregor. Long Beach, however, long known for being more tolerant and ecumenical than the Vatican, which looked unkindly on this Ron Howard film for, among other things, suggesting that Jesus was a married father when he died, welcomed Hanks and the crew to film scenes in the outdoor pools on the east side of Belmont Plaza.

ANGELS IN THE OUTFIELD (1994)

Danny Glover, Christopher Lloyd, Tony Danza. Although most of the ball playing in this comedy took place at Angel Stadium, Long Beach's beautiful Blair Field was called in for some pinch-hitting scenes.

ANGER MANAGEMENT (2003)

Adam Sandler, Jack Nicholson, Marisa Tomei. Long Beach's scenic peninsula took on the role of Boston for this comedy. According to Long Beach Locations chief John Robinson, "The location scouts looked for places to shoot in New York and Boston and then decided Long Beach looks more like Boston than Boston does." A date scene gone horribly wrong between Sandler and Heather Graham was filmed at Bay Shore Walk and Sixty-fourth Place and on the beach in front of a residence at 6624 Bay Shore Walk.

ARMORED (2009)

Columbus Short, Matt Dillon, Laurence Fishburne.

ARMORED CAR ROBBERY (1950)

Charles McGraw, Adele Jergens, William Talman. This 1950 film-noir classic included scenes set in the spooky oil derrick landscape of Long Beach.

AS GOOD AS IT GETS (1997)

Jack Nicholson, Helen Hunt. The two stars won Oscars for their lead roles in this romantic comedy that was using the title "Old Friends" while filming in Long Beach in January 1997. The movie made great use of the former site of the Windrose Restaurant in Seaport Village before it reopened as Khoury's in what's now named Alamitos Bay Landing (formerly Seaport Village). The restaurant played the part of restaurant in Baltimore where Nicholson takes Hunt and botches the fledgling romance. Across the channel, crews also decorated the Seal Beach Pier with thousands of lights for a shot depicting a waterfront spot on the Chesapeake Bay.

THE ASTRONAUT'S WIFE (1999)

Charlize Theron, Johnny Depp.

THE AVIATOR (2004)

Leonardo DiCaprio, Cate Blanchett. In this biopic directed by Martin Scorsese, Howard Hughes (DiCaprio) meets Katharine Hepburn (Blanchett) when he comes ashore by the jetty at Seventy-second Place at the end of the peninsula. The wrap party for Hughes's *Hell's Angels* and the celebration in which Hughes announces his plans to build the Spruce Goose (which would fly just once, piloted by Hughes, in Long Beach) were both filmed in the Art Deco lounges aboard the *Queen Mary.*

THE BACHELOR AND THE BOBBY-SOXER (1947)

Cary Grant, Myrna Loy, Shirley Temple. The closing scenes in the film were shot at Daugherty Field (Long Beach Airport).

BAD SANTA (2003)

Billy Bob Thornton, Bernie Mac. Film crews followed Willie (Thornton) all over town for this comedy set in Florida. Willie tends bar on the beach at Alfredo's Kayak Cafe on Fifty-fourth Place at Alamitos Bay. Willie watches girls play volleyball at Harbor Plaza at Queensway Drive. Willie's apartment building is at 1161 Magnolia Avenue, and a not overly swank motel is played ably by the El Capitan Motor Inn at 446 West Pacific Coast Highway. Bad Santa brought some early Christmas vibes to the city when the Wal-Mart in downtown's CityPlace center was decked in tinsel and holiday flights for the shoot. Other Long Beach locations for the movie include the Reef Restaurant, the bathroom outbuilding by the *Queen Mary*, the First United Methodist Church of Long Beach on Pacific Avenue and the Mexico Tire & Auto Repair at 431 West Pacific Coast Highway.

BALLS OF FURY (2007)

Dan Fogler, Christopher Walken, George Lopez.

THE BANGER SISTERS (2002)

Susan Sarandon, Goldie Hawn. Scenes were filmed at Community Hospital of Long Beach, 1720 Termino Avenue.

BARB WIRE (1996)

Pamela Anderson, Amir Aboulela. The docks of Long Beach are made up to look their worst as they take on the role of the near-future dystopian Steel Harbor.

THE BAREFOOT EXECUTIVE (1991)

Kurt Russell, Joe Flynn and Harry Morgan.

BARTON FINK (1991)

John Turturro, John Goodman. The Coen Brothers' stylish Sardi's-type restaurant and bar, where Fink gets the call to the West Coast, was filmed in the Art Deco lounges of the *Queen Mary*.

BASEketball (1998)

Trey Parker, Matt Stone. David Zucker's sports comedy used up a lot of the city. Long Beach Airport had one of its most challenging roles playing the Calcutta, India, Airport, with Brahma bulls and rickshaw drivers wandering the street in front of the terminal. Joe and Doug (Parker and Stone) lived at 1011 East Forty-sixth Street in quiet California Heights. The neighborhood is also where the sport of BASEketball, a hybrid of hoops and baseball, is first played. Later, the game goes to Blair Field at Recreation Park. Joe visits a friend at the Veterans Administration Medical Center on Seventh Street. A particularly notable scene occurs in the 49'rs Tavern, 5660 East Pacific Coast Highway, with Parker and Stone watching *The Jerry Springer Show* on the bar's TV. They played a shots game, taking a blast of tequila every time a fight broke out on the fight-filled show. Some of the bar's locals got the chance to play themselves as extras in the shoot.

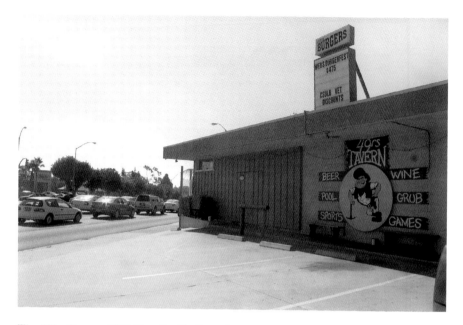

The 49'rs Tavern, 5660 East Pacific Coast Highway, had a big role in the 1998 movie *BASEketball*. Many of the tavern's locals and employees got to join in the filming. *Hannah Grobaty.*

BATMAN & ROBIN (1997)

Arnold Schwarzenegger, George Clooney and Chris O'Donnell. Again filmmakers used the sixty-foot-tall Bat Cave and Wayne Manor in the Spruce Goose Dome.

BATMAN FOREVER (1995)

Val Kilmer, Tommy Lee Jones and Jim Carrey. After the Spruce Goose left its dome home in 1992 to move to Oregon, filmers began using the massive room for a soundstage. The Bat Cave and Bruce Wayne's manor were built inside the dome for Batman Forever.

Batman Forever and *Batman & Robin* were filmed inside the Queen Mary Dome where crews built the Bat Cave and Bruce Wayne's Manor.

THE BEAST FROM 20,000 FATHOMS (1953)

Paul Hubschmid, Paula Raymond. Based on a story by Ray Bradbury, a ferocious dinosaur is unleashed in a nuclear bomb test in the Arctic. The climactic final scenes were filmed at the Pike, playing the role of the Coney Island amusement park in New York. A sharpshooter carrying a specialized weapon rides the Cyclone Racer to the top where it can be at eye-level with the killersaurus. Special effects included live shots of the actors with Pike footage in the background, and a miniature model of the Cyclone Racer was built to be destroyed by the monster.

BECAUSE I SAID SO (2007)

Diane Keaton, Mandy Moore.

BE COOL (2005)

John Travolta, Uma Thurman, Dwayne Johnson. John Travolta's a regular sight in Long Beach. He keeps his jet at Long Beach Airport, and he's appeared in a number of films shot in Long Beach (do you want us to remind you of *Perfect* again?). For this Elmore Leonard story, Travolta was back in town with sidekick Danny DeVito. The actors were filmed on the Convention Center steps for this sequel to their great *Get Shorty*.

BEDAZZLED (2000)

Brendan Fraser, Elizabeth Hurley.

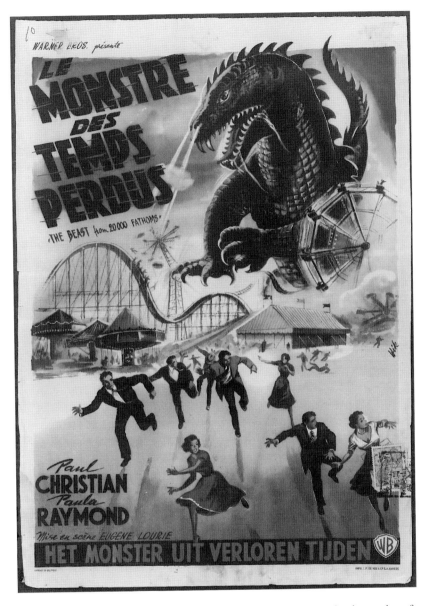

Among the special effects used in *The Beast from 20,000 Fathoms* was the destruction of the Pike's Cyclone Racer. Crews built a miniature model of the thrill ride for the shot.

BEDTIME STORIES (2008)

Adam Sandler, Keri Russell, Courteney Cox. For the most part, filmmakers like to keep their projects under wraps, and, generally, so do the city's special events officials. It's frequently difficult to find out what's going on around town when crews show up. For the trailer and ads for Disney's *Bedtime Stories*, a key scene includes thousands of brightly colored gumballs raining on Skeeter Bronson (Sandler). The candy storm is the result of a candy truck getting in an accident on Queensway Bridge, which spans the Los Angeles River, connecting downtown Long Beach to the *Queen Mary*. The gumball cargo from the truck rains down on Skeeter on Seaside Way below.

To get the shot in late February 2008, Disney had been blocking or rerouting traffic in and around the Port and intermittently closing the Queensway Bridge. People hired for security and to make sure non-filming cars didn't motor around all willy-nilly kept what they imagined to be a shroud of secrecy over the project.

One such fellow, standing by a big rig that bore an advertisement for Sweet Tooth Candy, told photographer Thomas Wasper that what was being filmed was "no big deal" and that "nobody famous" was starring in it. Move along, nothing-to-see.

Our lensman, noting the mammoth candy truck, asked Security Man if it was a candy commercial that was being filmed and the keeper of secrets (turned bald-faced liar) paused for a second before thinking on his feet. "Yes," he said. "It's a candy commercial."

The security guy also told Wasper that he couldn't take any pictures— something we hear all the time despite the fact that filming is going on in public on city and state streets—but we don't pay our snapshooter to stand around chatting with storytellers all day. He got the shot.

Things were even less exciting for the film's star, who had to put in long hours hanging around in his trailer. It's hard work being a huge movie star. And that is precisely why we aren't one.

There are some upsides to being a famous star, though, and we saw how that side works when Sandler expressed a desire to "his people" to shoot some recreational hoops between *Bedtime Stories*.

His people got in touch with local locations expert, John Robinson, who had booked Sandler into St. Anthony High School's gym for the 2005 remake of *The Longest Yard*. So, Robinson reacquired the same location for Sandler's hoops-shooting relaxation/diversion.

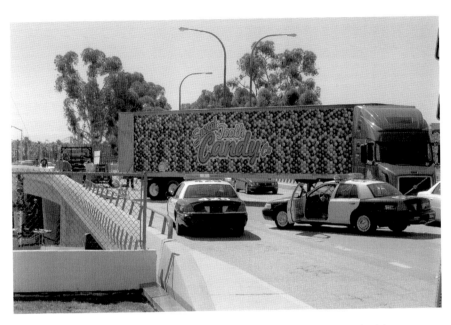

A candy truck gets in an accident on Queensway Bridge with sweet results in Adam Sandler's *Bedtime Stories*. *Thomas Wasper.*

We asked him if he'd done any head-to-head hoops with Sandler, and he mentioned that he did try playing a bit. "I missed everything. Technically, I wasn't shooting hoops, I was just throwing a basketball," said Robinson.

"Sandler drained all his shots. He was great," said Robinson, but then again, he's in the business, so what else would he say?

BEING JOHN MALKOVICH (1999)

John Cusack, Cameron Diaz. A bar scene in which Malkovitch (played by John Malkovich) explores his own consciousness was filmed in a bar on the *Queen Mary*.

BEST DEFENSE (1984)

Dudley Moore, Eddie Murphy, Kate Capshaw.

THE BEST YEARS OF OUR LIVES (1946)

Fredric March, Dana Andrews, Myrna Loy. A scene in this film (that won seven Oscars) showing Dana Andrews lugging his overstuffed suitcase across the terminal, looking for a flight home, was shot at Long Beach Airport.

THE BIG LEBOWSKI (1998)

Jeff Bridges, John Goodman, Julianne Moore. The Coen Brothers brought a cool cast, including Goodman, Bridges and Steve Buscemi, to Long Beach's Public Works' maintenance yard early last spring to film some scenes for the bowlers-gone-bad flick.

BIG TROUBLE (2002)

Tim Allen, Rene Russo.

BLACK MOON RISING (1986)

Tommy Lee Jones, Linda Hamilton, Robert Vaughn.

BLADE (1998)

Wesley Snipes, Stephen Dorff, Kris Kristofferson. The comic book–inspired horror movie starring Snipes as a vampire hunter was filmed in part at St. Mary Medical Center in Long Beach. It's a desirable location for a couple of reasons. The hospital has plenty of parking for film crews, and it has a vacant floor—its old morgue—so interference with hospital work is minimal.

BLOOD WORK (2002)

Clint Eastwood, Jeff Daniels. Eastwood and Daniels are live-aboard boat neighbors at Downtown Marina's Gangway G. This was almost a travelogue film for Long Beach because, for once, the city didn't have to get tarted up with makeup to play some other town. The 2002 film used Long Beach for what it is, with beautiful scenery including the skyline and lots of shots using the *Queen Mary* as a backdrop.

BLOW (2001)

Johnny Depp, Penélope Cruz. Crews and "talent" filmed on the beach at the foot of the Peninsula in Belmont Shore, as well as inside a home on the 5300 block of Ocean Boulevard in Belmont Shore.

BLUE THUNDER (1982)

Roy Scheider, Warren Oates. Scheider captains a helicopter with post-crash scenes filmed on Anaheim Street at California Avenue.

BODY DOUBLE (1984)

Craig Wasson, Melanie Griffith. Scenes include filming at the Beach Terrace Motel at 1700 East Ocean Boulevard, a nearby bluffside residence at 33 Eleventh Place and a chase into a now-sealed tunnel south of Bixby Park.

THE BODYGUARD (1992)

Kevin Costner, Whitney Houston. Several movies, TV shows and commercials have been filmed at Long Beach's iconic tavern Joe Jost's, 2803 East Anaheim Street, but none so memorable as *The Bodyguard*. A long scene

Filmers get a close-up of actor Roy Scheider after his chopper "crashes" on Anaheim Street at California Avenue in *Blue Thunder. Courtesy of* Press-Telegram.

Actor Gregg Henry is filmed in a chase scene on the beach at the foot of Cherry Avenue for the 1980 film *Body Double. Courtesy of* Press-Telegram.

with Kevin Costner and the late Whitney Houston showed the two meeting over beers in the front part of the tavern before moving to the back room for a lovely dance.

"She was very nice," recalls Jost's owner Ken Buck of the star. "So was Costner. For as big of stars as they both were, it was very casual. They weren't surrounded by security or anything. Everybody just seemed very relaxed."

The filmers, says Buck, wanted to make a lot of changes in the venerable tavern on Anaheim at Temple Avenue.

"They had to remove the pool tables in the back so there was room for Costner and Whitney to dance, and they put in a jukebox. They wanted to take out some booths and replace them, but I talked them out of it. They were willing to pay a lot of money to do it, but they ultimately decided they didn't need to."

THE BORN LOSERS (1967)

Tom Laughlin, Elizabeth James. This forgettable motorcycle gang flick includes scenes shot at Lincoln Park.

BOWFINGER (1999)

Steve Martin, Eddie Murphy and Heather Graham: Downtown Long Beach's Pine Avenue was virtually rebuilt for a few weeks for the summer 1998 filming of this comedy. Stars Martin, Murphy and Graham were regularly seen on the street most days.

Cal State Long Beach grad Martin, who also wrote the screenplay, was on Pine on several mornings checking out locations and rehearsing (with no crews or cameras) scenes. He and director Frank Oz chatted about camera angles and other bits of arcanity in front of Alegria restaurant, planning a rather sedate restaurant shot, featuring the film's three stars.

"It shouldn't cause much disruption to business," said Alegria owner Terry Antonelli before the shoot. "Nothing's going to blow up; they'll just be sitting there eating."

In making dowdy Pine into glitzy Beverly Hills, several façades were given a makeover. One vacant downtown restaurant was transformed into the

Rodeo Grille, while farther north on Pine, the street was given a Fairfax look, with Gold's Gym turned into Goldblatt's Delicatessen. Another vacant store was built up as a swank gents' shop called MAX (in which we'd later find our star Eddie Murphy purchasing some threads before Martin and his people tried to kidnap him, chasing him out of the store onto a bus) on the east side of the street, nestled in behind some planters (bogus: thump 'em, and they sounded like you're whacking a cardboard box).

And, next to Gold(blatt)'s, they converted a vacant shop into a swinging swing-and-blues music club called Club Jump, including a ritzy Art Deco interior (into which Murphy would continue his flight from his bumbling would-be starnappers).

BOUNCE (2000)

Ben Affleck, Gwyneth Paltrow. Paltrow and Affleck showed up in early November 1999 to film the setup for the movie, in which a guy (Affleck) trades a ticket in the airport (LGB) with a total stranger, in order to have an eleventh-hour fling with some floozy. The plane then crashes, leaving the Affleck character wracked with guilt, so he looks up the widow (Paltrow) of the dead passenger, and he falls in love with her. Additional scenes were filmed at the famed Johnie's Broiler in Downey.

BREWSTER'S MILLIONS (1985)

Richard Pryor, John Candy. Long Beach-born director Walter Hill shot some street scenes for the comedy in his hometown.

BRING ME THE HEAD OF ALFREDO GARCIA (1974)

Warren Oates, Isela Vega. No scenes of this gaudily violent Sam Peckinpah film were shot in Long Beach, but a preview of the film was shown at the Towne Theater on Atlantic, with Peckinpah in attendance. The crowd filled out response cards, with reportedly scathing grades for the movie.

THE BROKEN HEARTS CLUB: A ROMANTIC COMEDY (2000)

Timothy Olyphant, Dean Cain. Restaurant exteriors and interiors.

THE BROTHERS SOLOMON (2007)

Will Arnett, Will Forte, Jenna Fischer.

THE CABLE GUY (1996)

Jim Carrey, Matthew Broderick. Filmed aboard the *Queen Mary*. Also, Chip's (Carrey) retreat, a sixty-foot cable dish, was built inside the adjacent Spruce Goose Dome.

CAPRICORN ONE (1977)

Elliott Gould, James Brolin. Conspiracy 'naut Gould loses his brakes on the streets of Long Beach.

CEMENT (2000)

Chris Penn, Jeffrey Wright

CHAIN OF COMMAND (2000)

Roy Scheider, Patrick Muldoon. Scenes were shot aboard the *Queen Mary*.

CHANGELING (2008)

Angelina Jolie, Colm Feore.

CHAPLIN (1992)

Robert Downey Jr., Geraldine Chaplin and Paul Rhys. The *Queen Mary* plays her old working self as Chaplin (Downey) sails to the United States aboard the ship, only to find he's been barred from the country.

CHARLIE'S ANGELS (2000)

Cameron Diaz, Drew Barrymore and Lucy Liu. Hollywood's favorite bridge, the Vincent Thomas, was used for a scene in which we see a race car speeding out of Fontana (forty miles away) and then appearing on the bridge.

CHARLIE'S ANGELS: FULL THROTTLE (2003)

The rugged and portly Berth 240 along Seaside Avenue was the spot where we see Lucy Liu going crazy with a flamethrower.

CHARLOTTE'S WEB (2006)

Dakota Fanning, Julia Roberts, Oprah Winfrey.

CHEAPER BY THE DOZEN (2003)

Steve Martin, Bonnie Hunt, Hilary Duff. Scenes were filmed in Cabrillo High School's gym locker room, parking lot and gym.

CHILD'S PLAY 2 (1990)

Alex Vincent, Jenny Agutter. A waste management facility in the Port of Long Beach on Pier S Avenue at Henry Ford Avenue takes on the cheerful role of The Play Pals Toy Factory, where the evil Chuckie is rebuilt.

CHRISTMAS VACATION (1989)

Chevy Chase, Beverly D'Angelo.

CINDERELLA STORY (2004)

Hilary Duff, Chad Michael Murray: George's 50's Diner, 4390 Atlantic Avenue, played a big role in this film as the restaurant first owned by Duff's dad and then later by her evil stepmother (Jennifer Coolidge).

CLICK (2006)

Adam Sandler, Kate Beckinsale, Christopher Walken. After he accidentally fast-forwards past his father's death (long story, see the movie), Sandler visits his grave at Sunnyside Cemetery, 1095 East Willow Street. FXers blue-screened a New York City skyline behind the cemetery.

CLOCKSTOPPERS (2002)

Jesse Bradford, French Stewart, Paula Garcés. Opening scenes were shot at Long Beach Airport.

Sunnyside Cemetery on Willow Street was used to film a scene showing Adam Sandler visiting his father's grave in New York. The screen in the distance allowed effects teams to put the New York skyline in the background. *John Robinson/Long Beach Locations.*

CLUELESS (1995)

Alicia Silverstone, Stacey Dash, Brittany Murphy. A skateboarding scene was filmed at Shoreline Village.

COACH CARTER (2005)

Samuel L. Jackson. Poly High in Long Beach was used for some campus shots, but most of the hoops action took place in the St. Anthony High School gymnasium. The movie is about Ken Carter, a real-life high-school basketball coach from Northern California who had the kooky idea of putting studies and discipline over athletics. The coach himself visited St. Anthony during filming to sign autographs and talk to students. As for the ersatz coach, Samuel Jackson? Not so much. "He wasn't so great with the

kids," said Poly's co-principal. "He rode around in his golf cart from his trailer to the set. Kids would yell, 'Hey! Mr. Jackson!' but he wouldn't even make eye contact. It was kind of sad."

COBRA (1986)

Sylvester Stallone, Brigitte Nielsen. A wild and lengthy car chase starts in downtown Long Beach and moves onto the Terminal Island Freeway. Suddenly, the cars shoot down an alleyway in Culver City, then we're in Long Beach again, then Venice and finally we wind up in the Port of Long Beach. Now, that's a Hollywood car chase.

COLLATERAL (2004)

Tom Cruise, Jamie Foxx. Scenes were filmed in the Port of Long Beach including Anaheim Street, Pier A Way and Pier B.

COMMANDO (1985)

Arnold Schwarzenegger, Rae Dawn Chong. Long Beach Airport's terminal takes on the role of Aeropuerto Val Verde in Hollywood's frequently used fictional South American country of Val Verde.

THE CONRAD BOYS (2006)

Justin Lo, Booboo Stewart.

CONSTANTINE (2004)

Keanu Reeves, Rachel Weisz. Scenes were shot at St. Mary Medical Center, 1050 Linden Avenue.

CORKY ROMANO (2001)

Chris Kattan, Peter Falk.

CORRINA, CORINNA (1994)

Ray Liotta, Whoopi Goldberg. Long Beach scenes include a rare stop in the Carroll Park neighborhood.

COYOTE UGLY (2000)

Piper Perabo, Adam Garcia, John Goodman. The opening five minutes of the film were shot at the old DiPiazza's Lava Lounge in the dearly departed Java Lanes on Pacific Coast Highway.

THE CRAFT (1996)

Robin Tunney, Neve Campbell. Scenes were filmed at the Poly High swimming pool.

CRASH (2004)

Don Cheadle, Sandra Bullock. A pivotal crash scene was filmed in Long Beach.

THE CROSSING GUARD (1995)

Jack Nicholson, David Morse, Anjelica Huston. This film, written and directed by Sean Penn, includes scenes shot at the Port of Long Beach.

CROSSING OVER (2009)

Harrison Ford, Ashley Judd, Ray Liotta. Though the title refers to border crossing, you could get a different idea by the fact that the film includes scenes shot at the morgue at St. Mary Medical Center. Ford was the only one of the stars to be filmed at the med center. Some ICU nurses, who could holler out the windows along Eleventh Street and wave at Ford, did just that—and he waved back, not being one of those snobbier guys that you sometimes see at film shoots. We're looking at you, Tom Cruise and Michael Jordan.

THE DANCING MASTERS (1943)

Stan Laurel, Oliver Hardy. Our boys rode a double-decker bus on the Cyclone Racer at the Pike for a highlight of this comedy.

DEADLINE AUTO THEFT (1983)

H.B. Halicki, Hoyt Axton. A must-have for your collection of auto-theft movies filmed in Long Beach. Scenes were shot all over the *Queen Mary*, including Mary's Gate Village and in the Queen Mary Seaport underground garage.

DEFENDING YOUR LIFE (1991)

Albert Brooks, Meryl Streep, Rip Torn. Scenes were filmed at El Dorado Park.

DEMOLITION MAN (1993)

Sylvester Stallone, Wesley Snipes, Sandra Bullock.

DENIAL (1998)

(*Something about Sex* is the video title.) Jonathan Silverman, Leah Lail. The Ice Dogs just missed bagging the Turner Cup in the 1997 season, but the now-defunct Long Beach hockey squad broke into show biz when Hollywood showed up at the Long Beach Arena to shoot some hockey-action footage on June 11 during Game Four of the series (the Dogs lost to the Detroit Vipers, if you're just tuning in) for this film featuring *Seinfeld* co-star Jason Alexander (sporting ersatz hair in his role), with Jonathan Silverman (of the TV sitcom *The Single Guy*) and Christine Taylor (who plays Marsha in *The Brady Bunch* feature films).

According to an Ice Dog publicist, the *Denial* filmmakers needed a live arena sporting event for the shoot, which shows Alexander scrambling from the nosebleed section down to the prime floor seats. And all that was available in the real world—with the regular NBA season wrapped up, college hoops long finished and the Stanley Cup in the books—was the Hollywood-close Turner Cup game in Long Beach or a costly and logistically nightmarish road trip to the Chicago Bulls-Utah Jazz final.

The decision to use the Long Beach Arena was a slam-dunk.

DINNER FOR SCHMUCKS (2010)

Steve Carell, Paul Rudd. Tim (Rudd) goes to a fancy downtown restaurant to meet with some important clients who are anxious to meet his fiancée. A colossal mess ensues when Barry (Carell) shows up with a crazy girl posing as the future bride. The scene was filmed at The Madison restaurant at 102 Pine Avenue.

Feature Films Made in Long Beach

Crews work outside Pine Avenue's Madison Restaurant putting up scaffolding for lighting for an interior scene in 210's *Dinner for Schmucks*. *Thomas Wasper.*

In one of Long Beach's earlier roles as a Florida town, a Florida City patrol car gets in a fender-bender at Fifth Street and Chestnut Avenue in 1987's "Disorderlies." *Courtesy of Press-Telegram.*

DISORDERLIES (1987)

Darren Robinson, Damon Wimbley. One of Long Beach's early turns as a Florida town came with a brief shoot at Fifth Street and Chestnut Avenue with a staged crash involving cops from Florida City.

DODGEBALL: A TRUE UNDERDOG STORY (2004)

Ben Stiller, Vince Vaughn. Dodging cars (good practice for the game) was filmed on the 1200 block of Santa Fe Avenue on the west side. Nearby, Cabrillo High School was used for scenes showing cheerleader tryouts. Crews also filmed outside a residence in Belmont Shore.

DODSWORTH (1936)

Walter Huston, Ruth Chatterton. This film, based on a story by sometime Long Beach resident Upton Sinclair, was filmed in part on the *Queen Mary*—when it was still afloat.

DONNIE DARKO (2001)

Jake Gyllenhaal, Jena Malone. This odd film is practically an homage to Country Club Drive, the old-moneyed part of Long Beach in the Los Cerritos neighborhood. The residence at 4225 Country Club Drive is fairly well known by now to Long Beachers, who refer to it as the Donnie Darko House. Down the street, at 4252 Country Club Drive, is a way more expensive looking Tudor spread that played the home of self-help millionaire Jim Cunningham (Patrick Swayze).

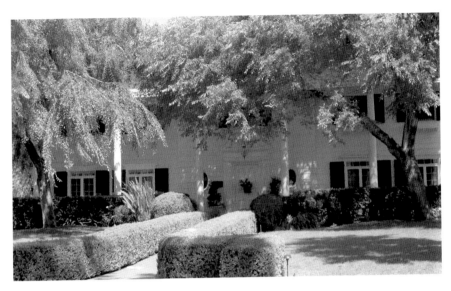

The "Donnie Darko" house is another frequently filmed location on filmmakers' beloved Country Club Drive. *Hannah Grobaty.*

THE DOORS (1991)

Val Kilmer, Meg Ryan. Oliver Stone, who also shot *Nixon* (well, you know what we mean) in Long Beach, used Long Beach Airport for his biopic on the Door's Lizard King, Jim Morrison.

DRIVEN (2001)

Sylvester Stallone, Burt Reynolds. The film opens with race scenes, including scenes from the Toyota Grand Prix of Long Beach.

THE DRIVER (1978)

Ryan O'Neal, Bruce Dern. Long Beach–born director Walter Hill filmed inside the Lafayette on First Street, including transforming a room into a casino. Chase scenes were also shot nearby.

DUDE, WHERE'S MY CAR? (2000)

Ashton Kutcher, Seann William Scott.

EAGLE EYE (2008)

Shia LaBeouf, Michelle Monaghan.

ED WOOD (1994)

Johnny Depp, Martin Landau, Sarah Jessica Parker.

8MM (1999)

Nicolas Cage, Joaquin Phoenix and James Gandolfini. Set builders threw up a little house right smack in the middle of one of the scariest places in Long Beach—the Sunnyside Cemetery on Willow Street—just so Long Beach native Cage and his nemesis could brawl and crash through a second-floor window to the hallowed ground below. The film was directed by *Batman & Robin*'s Joel Shumacher based on a script by Andrew Kevin Walker, who wrote the hypercreepy *Se7en*.

ESCAPE FROM L.A. (1996)

Kurt Russell, Steve Buscemi, Stacy Keach. Snake Russell has a hideout aboard the *Queen Mary* in disaster-riddled L.A. (Long Beach). He meets his old pal Herse Las Palmas (Pam Grier), and they launch themselves in hang gliders from the deck of the ship.

EXECUTIVE SUITE (1954)

William Holden, Barbara Stanwyck, June Allyson. Almost as impressive as the cast is some great footage of the Art Deco terminal at Long Beach Airport. Fredric March tails Paul Douglas to the airport to humiliate him by catching him in a tryst with Shelley Winters.

THE FAN (1996)

Wesley Snipe, Robert De Niro. The venerable and tragically defunct country music club The Foothill, in Signal Hill, was used for bar scenes in this thriller. The club's women's bathroom was also used for a murder scene.

FAREWELL, MY LOVELY (1975)

Robert Mitchum, Charlotte Rampling. Lots of local scenery here, including a scene at a Pike arcade, plus the classic line by Mitchum/Philip Marlowe: "This car sticks out like spats at an Iowa picnic," in reference to the once-mammoth Long Beach event. Scenes were also filmed aboard the *Queen Mary*.

FAST AND FURIOUS (1939)

Franchot Tone, Ann Sothern. There's a disappointing absence of methamphetamine-fueled carjacking in this Busby Berkeley–directed comedy-mystery. Just some nice, sedate shots of Rainbow Pier and surrounding landmarks.

THE FAST AND THE FURIOUS (2001)

Vin Diesel, Paul Walker. Seems like Hollywood can't make a car chase/theft movie without availing itself of the easily (though inconveniently) closeable Vincent Thomas Bridge. Happens here, too. Also, the truck-hijacking scene at the start of the film was filmed down by the docks on the Wilmington–Long Beach border in the vicinity of Henry Ford Avenue and Anaheim Street.

THE FAST AND THE FURIOUS: TOKYO DRIFT (2006)

Lucas Black, Zachery Ty Bryan. More rubber-burning around the port, and Long Beach's Chavez Park was called into service for some scenes for this sequel.

FASTER (2010)

Dwayne Johnson, Billy Bob Thornton. The killer (Oliver Jackson-Cohen) can be seen taking out the trash at the Casa Grande condominiums in Belmont Heights.

FERRIS BUELLER'S DAY OFF (1986)

Matthew Broderick, Alan Ruck, Mia Sara. If there's a more famous filmed residence in Long Beach than the *Donnie Darko* House, it's the *Ferris Bueller* House, just up the street at 4160 Country Club Drive. The same house was used in *Not Another Teen Movie*, and it was bloodied up good for *Silence of the Lambs* prequel *Red Dragon*.

Tired of Country Club Drive shots yet? Hollywood certainly isn't. This is the star home in *Ferris Bueller's Day Off*. The residence also had roles in the spoof flick *Not Another Teen Comedy* and the grisly *Silence of the Lambs* prequel, *Red Dragon*. *Hannah Grobaty.*

A FEW GOOD MEN (1992)

Tom Cruise, Jack Nicholson, Demi Moore. Crews made more use of San Pedro than Long Beach, especially at Fort MacArthur, but they did do some filming in the Port of Long Beach.

FIGHT CLUB (1999)

Brad Pitt, Edward Norton. Good ol' Shipwreck Joey's, a topless bar in Wilmington (close enough: you could see it from Long Beach), was the main location for club-fightin' in this weird (because, you know, Chuck Palahniuk) film that made great use of the seamy-looking dockside location. Joey's was officially wrecked after the movie was filmed. Nothing to see there now on B Street.

FINAL VOYAGE (1999)

Dylan Walsh, Ice-T. Something goes pretty wrong with a luxury cruise ship in this film. The *Queen Mary* does her part with interiors.

FIRED UP! (2009)

Eric Christian Olsen, Nicholas D'Agosto. Four Southern California high schools and a college were used in this raunchy comedy about a couple of popular prep footballers who ditch practice to spend two weeks at cheerleader camp. Thank God our beloved Wilson High didn't stoop so low. Poly High, on the other hand, did.

FIRST SUNDAY (2008)

Ice Cube, Katt Williams, Tracy Morgan. The East Village Arts District was filthied up by set designers to look like it did back in its crack-house days. A fake liquor store was one of the highlights, plus extras roaming around like hobos.

FLETCH (1985)

Chevy Chase, Joe Don Baker. A car chase was filmed in Long Beach.

FOREIGN CORRESPONDENT (1940)

Joel McCrea, Laraine Day. Long Beach gets plenty of shots in Alfred Hitchcock's thriller, as well as some footage on the pre-LB *Queen Mary*. Of further local note, the film's co-star Laraine Day grew up in Long Beach and paid her early dues as a member of the Long Beach Players.

FORGET PARIS (1995)

Billy Crystal, Debra Winger. Remember Billy Crystal getting stuck in traffic with his sperm sample? That was on Shoreline Drive at the end of the Long Beach Freeway.

FOR THE LOVE OF THE GAME (1999)

Kevin Costner, Kelly Preston. Kevin Costner's other baseball epic, *For the Love of the Game*, features a couple of scenes in which he and co-star Preston take a stroll at the end of Naples Plaza Drive and chat outside the Crab Pot restaurant near the Alamitos Bay Landing.

FRACTURE (2007)

Anthony Hopkins, Ryan Gosling. Movie crews were at the Walker Lofts on Pine Avenue for some shots of Sir Hopkins and regular-guy Gosling before moving across town to film scenes at the Long Beach Airport.

FREEDOM WRITERS (2007)

Hilary Swank, Imelda Staunton, Patrick Dempsey: Don't get us started. *Freedom Writers*, based on the book and experiences of Wilson High teacher Erin Gruwell and her class, chewed up local scenery in March 2006, using a number of sites, including streets and alleys on Willow Street in West Long Beach and at Shoreline Park. The latter scene required a cast and crew of four hundred—a record for the month!

Hollywood has always had a love-hate relationship with verisimilitude. Sometimes, filmmakers will run out and spend millions or go to some other ridiculous lengths to get every little detail correct. Other times, they'll leave precision on the cutting room floor if it gets in the way of a good story or otherwise slows things down. Audiences will see a little bit of both methods of dealing with reality in *Freedom Writers*.

Based on the 1994 experiences, and subsequent book, of first-year English teacher Erin Gruwell and the inspirational turning-around of her at-risk, or "unteachable," students at Long Wilson, the film stars Hilary Swank portraying Gruwell.

The filmmakers' attention to detail is such that they recreated Gruwell's Wilson classroom, Room 203, at the Paramount lot. For other high-school scenes, however, they took a pass on the Wilson campus itself and instead hired a couple of stand-ins: Westwood's University High School and L.A.'s Hamilton High.

Wilson had been all set to make a fairly rare film appearance in the movie, even to the point where, according to a school co-principal, a tentative agreement had been reached among the school district, the filmmakers and an L.A.-based location service. But things fell apart in negotiations, and Paramount took the path of shooting exterior, hallway and quad scenes at schools closer to the studio. Ironically, the money that was to have gone to Wilson would have been used to help the school's English department.

"We were going to buy sets of in-class books for the department," the co-principal told us. "You have a son here (yes, we did), so you know how heavy those books are. With sets in the classroom, they could leave their books at home and not have to carry them in their backpacks everywhere they go."

That's right. It's about family now. It's personal.

Meanwhile, Gruwell took things in her typically sunny manner. "The classroom they've built is a spitting image of my room," she told us. "And they'll be filming some things in Long Beach: an apartment building, a mini-mart, some scenes at Martin Luther King Jr. Park. There'll certainly be plenty of Long Beach in the picture."

While it's true that most, if not all, of the 150 students who gained success as Erin Gruwell's Freedom Writers came from sub-poverty-level or otherwise troubled families or backgrounds, there was a bit of sensitivity about the whole school being portrayed as a dangerous campus living under gang rule.

FUN WITH DICK AND JANE (2005)

Jim Carrey, Téa Leoni, Alec Baldwin. Filming took place on Pine Avenue and Seventh and Eighth Streets.

GARFIELD: A TALE OF TWO KITTIES (2006)

Breckin Meyer, Jennifer Love Hewitt. Filmers were in town in early October 2005 shooting scenes for the feline follow-up on Ocean Boulevard along Bluff Park.

GET SMART (2008)

Steve Carell, Anne Hathaway, Alan Arkin.

GIGLI (2003)

Ben Affleck, Jennifer Lopez. The best part of this film is the presence of the great Casa Sanchez Mexican restaurant at 3948 East Anaheim Street.

THE GIRL NEXT DOOR (2004)

Emile Hirsch, Nicholas Downs. The 4100 block of Country Club Drive scores another credit in this movie that used the *Donnie Darko* House for a wild teen party, with a streaking scene down the block as well.

THE GIRL WHO KNEW TOO MUCH (1969)

Adam West, Nancy Kwan. A highlight from this caper flick involves a fight between West and a villain in the old Sutton Place Antiques that was on Broadway at Redondo Avenue, across from the Reno Room. The fight ended with a mammoth explosion and the demolition of the shop. Pre-blast scenes were shot at the store, while a duplicate of the shop was built at the studio and blown to bits. The also-departed Mr. C's Restaurant on Pacific Coast Highway was also featured in the movie.

THE GLASS BOTTOM BOAT (1966)

Doris Day, Rod Taylor, Arthur Godfrey.

GLEAMING THE CUBE (1989)

Christian Slater, Steven Bauer, Tony Hawk. This sk8r epic concludes with a crazy chase scene through the highways around the waterfront at Oceangate, including Shoreline Drive, Queen's Way and Golden Shore.

A GNOME NAMED GNORM (1990)

Anthony Michael Hall, Jerry Orbach.

THE GODFATHER: PART II (1974)

Al Pacino, Robert De Niro, Robert Duvall. Scenes were shot aboard the *Queen Mary*.

GONE FISHIN' (1997)

Joe Pesci, Danny Glover. Includes fishin' scenes shot at the Los Cerritos Channel.

GONE IN 60 SECONDS (1974)

H.B. Halicki, Marion Busia. The film that launched a thousand car thefts made great use of Long Beach streets, including those around Lincoln Park and the Vincent Thomas Bridge with the Long Beach PD hot on his trail in an epic thirty-four-minute car chase that included the demolition

of more than ninety cars. Scenes were also shot at the *Queen Mary* and the International Tower at 700 East Ocean Boulevard.

GONE IN SIXTY SECONDS (2000)

Nicolas Cage, Angelina Jolie. This update followed much of the same ground as the 1974 original (you will note the slight title change), including making use of the International Tower. There's also a great chase scene in the abandoned Long Beach Naval Shipyard on Ocean Boulevard and Navy Way. And, of course, the Vincent Thomas Bridge plays a role, too.

THE GOOD GERMAN (2006)

George Clooney, Cate Blanchett.

GORILLA AT LARGE (1954)

Cameron Mitchell, Anne Bancroft, Lee J. Cobb. Fairly (and unintentionally) hilarious, *Gorilla at Large* features a gorilla—or is it a guy in a gorilla suit?— going amok at the old Nu Pike (here, it's the sinister Garden of Evil). It could be the Pike's biggest role. You'll see plenty of the old fun zone, including Laff in the Dark and the Cyclone Racer.

GRAND CANYON (1991)

Danny Glover, Kevin Kline, Steve Martin. There's lots of Long Beach streets scenery, particularly when Roberto (Jeremy Sisto) is learning to drive. You'll see him careening down Atlantic, hanging a right at Eighth Street and heading east on First Street trying to make a left onto Linden Avenue in the East Village.

GREASE 2 (1982)

Michelle Pfeiffer, Maxwell Caulfield. Long Beach scenes include El Dorado Regional Park, 7550 East Spring Street.

THE GUARDIAN (2006)

Kevin Costner, Ashton Kutcher.

GUESS WHO (2005)

Ashton Kutcher, Bernie Mac. This updated version of the 1967 classic *Guess Who's Coming to Dinner* was going under the working title *The Dinner Party* when filmers were in town shooting a residence on Cartagena Street in the Bixby Highlands section of town.

GUMBALL RALLY (1976)

Michael Sarrazin, Tim McIntire, Raul Julia. Scenes were filmed in the Long Beach Harbor and at the *Queen Mary*.

GUNSHY (1998)

William Petersen, Michael Wincott, Diane Lane. This heavy-drinking, heavy-killing film was mostly shot in Atlantic City, but the crew also grabbed a scene at St. Mary Medical Center in Long Beach.

HALF ANGEL (1951)

Loretta Young, Joseph Cotten, Cecil Kellaway. Several scenes from the Pike are visible in this movie, including the Cyclone Racer.

HANGING UP (2000)

Diane Keaton, Meg Ryan, Lisa Kudrow.

THE HAUNTING (1999)

Liam Neeson, Catherine Zeta-Jones, Owen Wilson. *The Haunting* sets built in the Long Beach dome were huge and tremendously Gothic. The largest was the 225-foot-long Great Hall, with its 50-foot-tall stone columns and a massive staircase.

HEAD (1968)

Peter Tork, Davy Jones, Micky Dolenz. Director Bob Rafelson reenacted the grand-opening ceremonies on the Vincent Thomas Bridge, only this time the event was disrupted by the Monkees as they scamper up—and in Micky's case, off—the bridge fleeing from the bad guys.

HEART & SOULS (2003)

Robert Downey Jr., Charles Grodin.

HEAT (1995)

Al Pacino, Robert De Niro, Val Kilmer. St Mary Medical Center, 1050 Linden Avenue, gets some good screen time in this thriller. De Niro's character, Neil McCauley, can be seen walking up to the hospital (the Holy Family statues at the front were replaced by a copy of Michelangelo's *The Pieta*), walking through the halls of St. Mary, then out the back where he steals an ambulance. The hospital appears again when Pacino brings his daughter to the emergency room for treatment when she attempts suicide. There are other scenes in Long Beach, including one at the Harbor Place Tower, 525 East Seaside Way. One reviewer wrote, "Director Michael (*Miami Vice*) Mann stylised the mean streets of Long Beach, Calif. in a beautiful representation of the underbelly of crime, U.S.A." Thanks for the kind words.

HE RAN ALL THE WAY (1951)

John Garfield, Shelley Winters. After a caper goes bad, small-time crook Nick (Garfield) hides out in the bathhouse at the Nu Pike amusement park, where he meets Peggy (Winters).

HE'S JUST NOT THAT INTO YOU (2009)

Jennifer Aniston, Jennifer Connelly. Scenes were filmed aboard the *Queen Mary*.

THE HIDEOUS SUN DEMON (1959)

Robert Clarke, Patricia Manning. After an atomic test goes bad—and don't they always?—a man turns into a monster every time he's exposed to the sun. Scenes filmed at the oil fields in Long Beach and Signal Hill. Best review we've seen about it: "Not the most exciting Sun Demon movie I've ever seen."

The Hideous Sun Demon featured some climactic shots filmed in and around Signal Hill. The movie prompted one critic to write: "Not the most exciting Sun Demon movie I've ever seen."

HIGH CRIMES (2002)

Jim Caviezel, Morgan Freeman, Ashley Judd. Scenes were filmed at the Poolside Inn Motel, 611 West Pacific Coast Highway.

HOLLYWOOD HOMICIDE (2003)

Harrison Ford, Josh Hartnett. In a bit of Hollywood ignoring real-world geography, there's a scene of the starring duo leaving Venice by way of the Vincent Thomas Bridge and heading into the rough-and-tumble port at Berth 240.

HOMEGROWN (1998)

Billy Bob Thornton, Hank Azaria, Kelly Lynch. Exterior scenes of Ocean Center Building at 110 West Ocean Boulevard.

HOW TO MAKE AN AMERICAN QUILT (1995)

Winona Ryder, Ellen Burstyn, Anne Bancroft.

IMITATION OF LIFE (1959)

Lana Turner, John Gavin, Sandra Dee. Docks in the Port of Long Beach played the docks of New York City.

THE INCREDIBLY STRANGE CREATURES WHO STOPPED LIVING AND BECAME MIXED-UP ZOMBIES!!? (1964)

Ray Dennis Steckler, Carolyn Brandt. This $38,000 monster epic was filmed largely on location at the Pike amusement park in Long Beach, which is meant to resemble a murky and sinister version of Brooklyn's Coney Island.

Audiences are treated to a tour of the old park, with good looks at the venerable Cyclone Racer and the always sort-of-dicey Laff in the Dark funhouse, featuring the cackling animatronic Laughing Sal and Laughing Sam and Blackie the Barker.

It was billed as the first monster musical, and we've seen nothing to contradict that bold statement. Just one month later, the No. 2 monster musical, *The Horror of Party Beach*, was released.

The film's poster maintained that not only was it filmed in Eastman Color, but also in Terrordrama, which, judging by the looks of the movie today, means muddy and scratchy. That wasn't enough: It was also billed as featuring "Hallucinogenic Hypnovision," which sounds like some sort of techno-acid but was merely a bunch of guys running into the theater at intervals to scare the crowd, in the off chance that the movie wasn't doing a good enough job.

The movie itself was written and directed by Ray Dennis Steckler, who also starred in the film using the pseudonym Cash Flagg.

We suppose we need a spoiler alert here, though, really, you're pretty dialed in on the plot after you read the title of the film.

Juvenile delinquent Jerry (Flagg/Steckler), his gal Angela and third-wheel Harold decide to have a nice time at a carnival.

Things go sideways pretty quickly with a dance number by an alcoholic woman; a stripper who hypnotizes Jerry, causing him to dump his girl to go see the stripper's act; and a fortune-teller who turns Jerry into a zombie by using a spiraling hypno-wheel, causing him to start killing people. Later, he runs off to the beach, where he's shot by the cops.

It's not as good as it sounds.

All this macabre mayhem is wrapped around musical numbers ("It Hurts," "Shook Out of Shape"), strip acts, swirling psycho-hypno effects, a hunchback who looks like the cover of Captain Beefheart's "Trout Mask Replica" and a revue of song-and-dance routines, many of which are filmed at the Pike, with others performed and filmed at an abandoned Masonic Temple in Glendale owned by Rock Hudson. We know: It's hard to believe this isn't a movie beloved by all.

Was *The Incredibly Strange Creatures Who Stopped Living and Became Mixed-Up Zombies !!?* the best zombie picture ever made? Perhaps not. That's still under discussion.

Was *The Incredibly Strange Creatures Who Stopped Living and Became Mixed-Up Zombies !!?* the worst zombie movie ever made? Perhaps. Probably. A 2004 DVD called *The 50 Worst Movies Ever Made* has it as the worst. Ever. Not worst zombie film; the worst film. The list-making website oddee.com had *The Incredibly Strange Creatures Who Stopped Living and Became Mixed-Up Zombies !!?* as the No. 1 worst movie title of all time.

Even so, the crew was not without talent. The cast, maybe, was without talent (though a young James Woods is rumored to have been among the extras), but not the cinematography staff.

The three lensmen on the film were Joseph V. Mascelli, who, as a civilian cinematographer for the Air Force, shot the aerial footage of the first H-bomb test at Bikini Atoll and wrote the biblical *The Five C's of Cinematography*; the late Laszlo Kovacs, who would go on to work on *Easy Rider*, *Ghostbusters*, *Miss Congeniality* and many other films; and Vilmos Zsigmond, who made *The Deer Hunter*, *McCabe and Mrs. Miller* and *Deliverance* and who won an Oscar for *Close Encounters of the Third Kind*.

THE INFORMANT! (2009)

Matt Damon, Tony Hale, Patton Oswalt.

AN INNOCENT MAN (1989)

Tom Selleck, F. Murray Abraham. Scenes were shot at the Long Beach Police Department and, more notably, at Shoreline Village, where a fake drug buy goes sideways and a shootout ensues.

THE INSIDER (1999)

Russell Crowe, Al Pacino, Christopher Plummer. Scenes were filmed at Poly High.

INTREPID (2000)

James Coburn, Costas Mandylor, Finola Hughes. A crack squad of navy ops are assigned to guard a VIP's daughter aboard a cruise ship. When a nuclear weapon goes off, things go sideways. *Intrepid* was filmed aboard the *Queen Mary*.

IRON MAN (2008)

Robert Downey Jr., Gwyneth Paltrow. The film climaxed with Robert Downey Jr.'s metalman and his/its robo-nemesis in a mammoth clash of steel and explosions in a freeway battle on Shoreline Drive.

THE ISLAND (2005)

Scarlett Johansson, Ewan McGregor. Car chase scenes were filmed around the Port of Long Beach.

THE ITALIAN JOB (2003)

Donald Sutherland, Mark Wahlberg, Edward Norton. A group of world-class thieves meets under the Gerald Desmond Bridge.

IT'S A MAD, MAD, MAD, MAD WORLD (1963)

Spencer Tracy, Milton Berle, Ethel Merman. Though it was filmed all over L.A., *It's a Mad, Mad, Mad, Mad World* is a great, if wacky, travelogue of early-1969 Long Beach. You get scenes along the Bluff; you get a glimpse of the Cyclone Racer. You get the old Imperial Hardware on Fifth Street, the original YMCA on Sixth, the Sears on Long Beach Boulevard, the Ocean Center Building, the Breaker, the Villa Riviera and more.

I WAKE UP SCREAMING (1941)

Betty Grable, Victor Mature, Carole Landis. Wait, Betty Grable was in town and I missed her? Scenes were filmed in the Plunge swimming pool at the Nu Pike.

I WANT TO GET MARRIED (2011)

Matthew Montgomery, Ashleigh Sumner

JACK FROST (1998)

Michael Keaton, Kelly Preston. The Spruce Goose Dome next to the *Queen Mary* was back in business as Warner Bros., which leased the dome for use as a giant soundstage, returned to work on its Christmas '98 big-bucks hopeful.

THE JANE AUSTEN BOOK CLUB (2007)

Kathy Baker, Emily Blunt, Amy Brenneman. Scenes around town include Purdy (Emily Blunt) dropping off her husband at Long Beach Airport and Purdy and Trey (Kevin Zegers) meeting in front of the Lakewood High School auditorium.

JARHEAD (2005)

Jake Gyllenhaal, Jamie Foxx.

JERRY MAGUIRE (1996)

Tom Cruise, Cuba Gooding Jr., Renée Zellweger. Long Beach scenes included filming at the Long Beach Airport Marriott Hotel, which played the part of a hotel in Miami. Also, a scene was shot at the Veterans Administration Medical Center on Seventh Street. At the latter, we stopped by with a photographer and held up filming for a while because the star (Cruise) refused to come out of his trailer until we left. In the name of art, we did.

JOE VS. THE VOLCANO (1990)

Tom Hanks, Meg Ryan, Lloyd Bridges. Scenes at a marina were filmed in Long Beach.

JOY RIDE (2001)

Leelee Sobieski, Steve Zahn, Paul Walker. *Joy Ride* shared the soundstage at the Queen Mary Dome with *Vanilla Sky* and *Pirates of the Caribbean* in 2000–2001, Some local street scenes were also used in the film.

JUDGMENT NIGHT (1993)

Emilio Estevez, Cuba Gooding Jr. Before the horror begins, a group of guys on their way to a boxing match get tied up in traffic. The snarl-up was filmed at the end of the Long Beach Freeway at the Shoreline Drive exit.

KEY TO THE CITY (1950)

Clark Gable, Loretta Young: Scenes were shot at Long Beach Airport.

KILLING ZOE (1993)

Eric Stoltz, Julie Delpy.

KING KONG (1933)

Fay Wray, Robert Armstrong. Scenes were shot at the harbor in Long Beach and nearby in San Pedro, including the landing at Skull Island.

KISS KISS BANG BANG (2005)

Robert Downey Jr., Val Kilmer, Michelle Monaghan. The film ends with a car chase and shootout and includes the scene of Harry (Downey) dangling from a freeway sign on Queensway, with additional shots filmed on surrounding roads and highways, including Shoreline Drive.

The Queensway Bridge, crossing the L.A. River by the *Queen Mary*, has been used for a number of films, including some great scenes in the Tom Cruise and Cameron Diaz thriller *Knight and Day*. *Hannah Grobaty.*

KNIGHT AND DAY (2010)

Tom Cruise, Cameron Diaz. A great scene shows the starring couple racing across Queensway Bridge, with images of Spain computer-generated in the background. The pair is being chased by a baddie in a Mercedes, who we see motoring along the bike path below. Additional fleeing is done by Cruise on foot at the bottom of the bridge and along Golden Shore.

L.A. CONFIDENTIAL (1997)

Kevin Spacey, Russell Crowe. This great L.A. noir film featured a cozy little neighborhood on Rose Avenue in Long Beach's California Heights for its opening scene, in which cop Bud White (Russell Crowe) comes upon a domestic dispute and rips down the wife-beater's Christmas decorations, to say nothing of what he does to the wife-beater.

LARRY CROWNE (2011)

Tom Hanks, Julia Roberts. The movie opens with credits showing Tom Hank's character (Larry Crowne) showing up at his job at a UMART discount store. That scene used a Kmart store in Burbank. Once inside, however, the scenes were shot at the Kmart at 2900 Bellflower Boulevard in Long Beach. Two scenes at a bank, one in which Crowne tries to refinance his home and another where he hands the loan documents to the banker and walks away from the debt, were filmed at the vacant Farmers & Merchants Bank, 3290 East Artesia Boulevard.

LAST ACTION HERO (1993)

Arnold Schwarzenegger, F. Murray Abraham. The Hyatt Hotel and its Rainbow Lagoon on South Pine Avenue were used for this action comedy. At a funeral on the hotel roof, our hero Schwarzenegger nabs the explosives-packed corpse of a mobster and, through a series of stunts, escapes and plunges into what turn out to be the La Brea Tar Pits—as portrayed by the generally sparkling Rainbow Lagoon. *Last Action Hero* was the first time the Queen Mary Dome was used for filming. Bad weather prompted director John McTiernan to use the giant space to build a soundstage so filming could continue apace.

THE LAST BOY SCOUT (1991)

Bruce Willis, Damon Wayans. The venerable Foothill Club on Signal Hill was tarted up as a strip club. After filming, it kept many of the fixtures installed by the crew, including the runway.

L.A. STORY (1991)

Steve Martin, Victoria Tennant. Freeway signs talk to Martin as he motors up Shoreline Drive.

A couple of Arnold Schwarzenegger stunt doubles gear up for a shot in *The Last Action Hero*, filmed at downtown's Hyatt Hotel and its Rainbow Lagoon. *Courtesy of* Press-Telegram.

LEAVE IT TO BEAVER (1997)

Christopher McDonald, Janine Turner. Glacial Gardens, at 3975 Pixie Avenue in Lakewood, was used as a neighborhood skating rink.

LETHAL WEAPON (1987)

Mel Gibson, Danny Glover, Gary Busey. The International Tower, 700 East Ocean Boulevard, is the setting for the opening scene. A young woman wakes up in bed, takes some drugs and jumps off the top-floor balcony

The International Tower on Ocean Boulevard shows up in a lot of Long Beach pictures, but perhaps never to such great effect as when a young woman fell from the top floor of the building in the opening scenes of 1987's *Lethal Weapon*. *Hannah Grobaty*.

to—we are not surprised—her death. While Gibson and Glover begin their investigation at the Tower, you get a good look at the Villa Riviera in the background down the street.

LETHAL WEAPON 4 (1998)

This se-se-sequel opens with what is unquestionably the most explosive scene filmed in Long Beach. We don't usually attend filming events in town, but who is going to pass up the chance to see a guy with a flamethrower burning up a good chunk of the East Village before being turned into a human torpedo and

blowing up an oil tanker and a service station? The action, for the most part, was on the 400 Block of East First Street. The big scene was delayed several times during the week before it finally went off at 2:30 a.m. We wrote at the time:

Just when you begin to wonder if a gas station will ever blow up, there she goes, with a strangely muted pfoompf, but otherwise with a thrilling, deeply satisfying and awesomely destructive force that rockets an oil tanker 40 feet into space (with the assistance of a crane) and sends a monstrous fireball billowing up and out into the misty early morning sky. Shouts of glee erupted from the small crowds of people who huddled against the chill as the explosion finally occurred.

The oil tanker twisted in the air before crashing to the ground on its back, and the sprawling canopy of the Unocal 76 gas station collapsed in an explosion of flame and smoke as Warner Bros. camera crews aboard a chopper, on rooftops, and in makeshift plywood shelters captured it all for the climactic finale of the opening scene for the sure-thing blockbuster film.

Mel Gibson and Danny Glover (Glover wearing only red boxer shorts and black shoes and socks—we can explain) sprinted down First Street in the phony movie rain, away from the soon to-explode service station built expressly for the purpose of destruction, and the hellish, yet amusing blast brought it all to an end.

Strangely, o'er the ramparts the onlookers watched as the orange-and-blue 76 ball was still gallantly spinning. Unocal should make their tanker hulls out of that plastic.

For the filming, in addition to the construction of the 76 station, a two-story facade was built for burning on the the corner of First Street and Linden Avenue, plus various fake storefronts were constructed in front of some of the existing shops on the street. Cars were brought in to be set on fire, ersatz trees were set up to be torched.

The source of all the fire was a flamethrower-wielding terrorist suited in full body armor who was filmed strolling down the street setting the town aflame.

Those who managed to get close enough to the set could get an idea of the setup from Gibson's and Glover's dialogue as they crouched behind their Crown Victoria cop car trying to figure out how to deal with Fire Boy.

"I've got an idea," shouted Gibson to Glover. "Take your clothes off."

After a bit of an argument—Glover is somewhat averse to scampering about in the rain in his boxers (red, with little white hearts)—Gibson says

the spectacle will create enough of a diversion to enable him to shoot the terrorist where he's vulnerable: right in the tank.

It works: Gibson's shot ignites the tank, turning Flame Boy into Rocket Boy, and jetting him, all aflame (by now he's a dummy, covered with duct taped explosives, glue and gasoline, yanked by a cable) into the tanker (thoroughly doused in a gasoline and contact-cement mixture) and blowing the whole shootin' works to hell.

The filming was the first time such an explosion was permitted in Long Beach, and it opened the doors to future blasts in the city. Nearby residents, perhaps predictably, were not amused. While the stars stay in well-appointed trailers and even hot tubs (there are two—for Gibson and Glover, of course) during the shooting and in Long Beach's deluxe hotels in the interim, the residents are, for the most part, stuck amid the clamor of shooting (as in guns shooting), set construction, diesel engines and the rest of the cinemacacophony that can be heard virtually around the clock.

Some weren't particularly enamored of Hollywood in their midst, such as Robert Burton, who lived at First and Elm. "The (location managers) have been rude, intimidating and pushy," he said. "The crews keep me up all night long. It's hurting my work, and I'm not being compensated for the hassle. I feel it's all being rammed down my throat. It's totally outrageous."

Sondra Villagrana, who lives in a nearby apartment house, was irked because she was told she couldn't even watch the filming from her balcony. Plus, "None of us can sleep at night with all the noise. We can't go outside to watch the filming, and it's all so the movie people can make money…I'm not so naive as to say that they can't make movies here; of course they can," she said. "But there has to be some consideration for those of us who live here."

Still, more typical—at least so far—is the feeling by Scott Baird, who lived in the Lafayette building on Linden Avenue, just north of First Street, with a fair view of the action below. "It's been troublesome, but they've been as good as they can be as neighbors under the circumstances," said Baird. "On one hand, it's been pretty noisy with the gunfire and other noise at three and four in the morning. I haven't got much sleep. But, on the other hand, it's good for the city to have this sort of thing going on. And, besides," he said, popping the cap off a beer bottle and sitting at his kitchen table to look out over the glitzy scene below, "it's fun to watch."

LICENSE TO WED (2007)

Mandy Moore, John Krasinski, Robin Williams. The First Congregational Church of Long Beach, 241 Cedar Avenue, plays the role of a Chicago Church, St. Augustine, every bit as credibly as Robin Williams plays its pastor, Reverend Frank. Much of the movie was shot in and at the church where Sadie (Moore) and Ben (Krasinski) intend to be married. First Congregational was featured heavily on the *Ally McBeal* TV series, which was filmed largely in Long Beach. *License to Wed* also shot scenes at Joe Jost's tavern on Anaheim Street.

LIFE AS A HOUSE (2001)

Kevin Kline, Mary Steenburgen. Interiors of Steenburgen's house were filmed in a home in Long Beach. Most of the filming took place in Palos Verdes, and the house of the title was built on the site that once was Marineland of the Pacific.

LITTLE CHILDREN (2006)

Kate Winslet, Jennifer Connelly, Patrick Wilson. Scenes were filmed at Long Beach Airport.

LITTLE FOCKERS (2010)

Ben Stiller, Teri Polo, Robert De Niro. Alamitos Bay Marina was used in the film.

LITTLE MARY SUNSHINE (1916)

Marie Osborne, Henry King. *Little Mary Sunshine*—now, that's an old movie. It was filmed at Long Beach's Balboa Studios, and we're not going to get

Baby Marie Osborne was one of Balboa Film's biggest stars. *Little Mary Sunshine*, made in 1916, was one of about thirty movies she made in Long Beach.

into the entire filmography of Balboa (check out Rodney Bardin and Jean-Jacques Jura's *Balboa Films: A History and Filmography of the Silent Film Studio* for the long story), but "Baby" Marie Osborne deserves a bit of a mention here.

Little Mary Sunshine was just one in a string of hits starring the Long Beach-based child star "Baby" Marie Osborne, who was brought to Long Beach by her foster parents when they moved to go to work for Balboa.

The movie, which clocks in at about fifty minutes—a virtual epic in those days—follows the Dickensian life of Miss Sunshine, who is left motherless and wanders the streets until she comes upon a young man freshly jilted by his sweetheart. Turns out our morose fellow was given the heave-ho because of his addiction to alcohol, and seeing that the little girl's aversion to the stuff causes her to be frightened, decides to turn over a new leaf and follow the path of righteousness.

At the time, Baby Osborne was a goldmine for Balboa. She starred in about thirty films and was rewarded with a humongous $300-per-week salary (this, when the average annual salary in the United States was $750). And Balboa president Herbert Horkheimer issued a proclamation of "Rules to be observed in regard to Little Mary Sunshine," which was handed out to all involved in filming her movies.

Among these pampering rules were:

She is not to be teased at any time.
She is not to be shouted at or addressed in slang.
She is not to be given sweetmeats nor presents of any description while at work on the stage or on location. All presents must be sent to her dressing room or left at the general offices of the studio.
Threatening or addressing the baby star in loud or unseemly language or using objectionable language in her presence shall be cause for instant dismissal.
She is not to be coddled nor handled unnecessarily. You must adore her from afar.

Marie Osborne Yeats died on November 11, 2010, in San Clemente, California, six days after her ninety-ninth birthday.

LITTLE MISS MARKER (1979)

Walter Matthau, Julie Andrews, Sara Stimson. Matthau and Stimson (taking on the role of Shirley Temple in this remake of the 1934 movie) spend a day at the Pike in the film.

LITTLE NICKY (2000)

Adam Sandler, Patricia Arquette. Filmmakers took on some six thousand extras to play fans in bleachers over a four-day shoot at the Pyramid at Cal State Long Beach for the filming of the Adam Sandler comedy.

THE LONGEST YARD (2005)

Adam Sandler, Burt Reynolds, Chris Rock. Locker room scenes were filmed at St. Anthony High School. The table tennis segment was filmed in the National Guard Armory at 854 Seventh Street. The police chase Sandler along Shoreline

Drive and into the Pike at Rainbow Harbor (not at all to be confused with, and only vaguely inspired by, the old Nu Pike amusement park). Additional scenes were filmed on Ocean Boulevard and the Commodore Heim Bridge.

THE LONELY GUY (1984)

Steve Martin, Charles Grodin. Scenes were filmed aboard the *Queen Mary*.

LOOKING FOR TROUBLE (1934)

Spencer Tracy, Jack Oakie. Tracy and Oakie play telephone linemen who deal with all manner of disasters, most notably the Long Beach Earthquake of 1933, which filmmakers made use of for this movie, made just weeks after the real disaster. Documentary footage of the actual quake is incorporated into the movie.

THE LOSERS (2010)

Idris Elba, Zoe Saldana, Columbus Short. Scenes were filmed at the Port of Long Beach.

LOST & FOUND (1999)

David Spade, Sophie Marceau. In a part of town already packed with diversions, Naples and Belmont Shore residents set up lawn chairs on the green against Alamitos Bay, along Bay Shore Avenue near Vista Street, to watch the filming of *Saturday Night Live* survivor David Spade in this film. The filmers used an apartment house at 291 Bay Shore Avenue. On one evening, a production assistant gave the delighted locals a crash course in Filmmaking 101 as the shooting went on across the water—as opposed to the usual technique of filmers keeping residents far at bay during filming.

LOVE DON'T COST A THING (2003)

Nick Cannon, Christina Milian. The school scenes were filmed at Long Beach Poly High.

LUCKY NUMBERS (2000)

John Travolta, Lisa Kudrow. Mostly filmed in Pennsylvania, the film includes a scene shot at the old Foothill Club in Signal Hill.

LUV (1967)

Jack Lemmon, Peter Falk, Elaine May. A house on Claremore Street in El Dorado Park Estates was leased for a week for scenes that involved Falk and May. Additional scenes, with Lemmon and May, were filmed at the Nu Pike. Also of some note, a twenty-five-year-old Harrison Ford appears in the film as Irate Motorist. It was his second big-screen appearance, following his 1966 debut in *Dead Heat on a Merry-Go-Round* as Bellhop Pager.

MADISON (2005)

Jim Caviezel, Mary McCormack. In a fine example of Long Beach's range, cameras filmed from a variety of angles to transform the Queensway Bay into the waters off Miami, Chicago and Seattle, as our hydroplaning hero battles his way to the top in a movie that was termed being the *Hoosiers* of hydroplaning.

MAMA'S BOY (2007)

Diane Keaton, Jon Heder, Jeff Daniels. We were walking down Long Beach Boulevard on a Friday in June 2006 when we came across an overstuffed leather chair in front of the legendary Acres of Books used bookstore. Being

lazy and unable to pass up any opportunity to flop into an overstuffed leather chair, we flopped into the chair, right next to a curiously strikingly attractive bald and naked female mannequin. Behind us were various items: an old suit of armor, a pair of mounted deer heads in cardboard cartons, a couple of old globes, some suitcases, a brace of mattresses, a few pieces of antique furniture, another overstuffed chair, some more mannequins.

While we chatted amiably with the naked fake lady, crewhands busied themselves by hauling the rummage inside—taking up the already scarce acreage left unfilled inside the venerable shop.

"It's the first time we've been in a movie," owner Jackie Smith told us. "We were in a couple of TV shows," she added, sort of dismissing the junior medium with a wave of her hand.

One of those small-screen roles was in the series *Good vs. Evil* that appeared first on cable's USA Network before being relegated to the SyFy Channel and, finally, out into clear, blue space, where canceled projects float around hoping to get picked up on distant planets. The other show no one could remember.

Acres of Books' film debut, then, would be *Mama's Boy*, a comedy in which Diane Keaton portrays Mama and *Napoleon Dynamite* star Jon Heder plays the title role, a self-absorbed pseudo-intellectual who lives with mom. He gets nervous and sabotage-minded when Mama starts dating and considering kicking her boy out of the house.

Lovers of Acres of Books were advised to not become alarmed when they see their beloved store renamed Warburton's Books during filming week.

MAME (1974)

Lucille Ball, Robert Preston, Bea Arthur. In one scene, Lucy and Robert Preston, who plays Beauregard Jackson Pickett Burnside, are seen strolling along the promenade deck of the *Queen Mary* as he sings "Loving You."

MAN ON THE MOON (1999)

Jim Carrey, Danny DeVito. Scenes showing Andy Kaufman doing nothing but reading *The Great Gatsby* in front of his audience were filmed at the Pyramid at Cal State Long Beach. Additional scenes were shot at St. Mary Medical Center.

MAN TROUBLE (1992)

Jack Nicholson, Ellen Barkin, Harry Dean Stanton. Scenes were shot at the Lite-A-Line at the Pike. Nicholson reportedly won on his first chance at playing the game.

MATILDA (1996)

Danny DeVito, Rhea Perlman, Mara Wilson. Filming was done on Pine Avenue and Third Street.

THE MEDICINE SHOW (2001)

Jonathan Silverman, Natasha Gregson Wagner. Filmed at an abandoned hospital in Long Beach.

MEET DANNY WILSON (1951)

Frank Sinatra, Shelley Winters. Stock footage of the *Queen Mary* was used.

MEGA PIRANHA (2010)

Paul Logan, Tiffany. The plot is simple (duh). A mutant strain of man-eating piranha develops—never mind how; It just develops, OK?—and gnaws its way into Florida. Sigh…Long Beach as Florida again? Couldn't the piranha gnaw its way into California itself, so we could quit with all the palm trees and gaudy coral-and-turquoise sets? The beach on Alamitos Bay along Bay Shore Avenue was used for the killer-piranha flick, as was the always cool-looking Haynes Generating Station along Studebaker Road.

MEN OF HONOR (2000)

Cuba Gooding Jr., Robert De Niro, Charlize Theron. The crew of *Men of Honor*—called *Navy Diver* at the time—worked in Long Beach for more than a month in the fall of 1999. The underwater scenes were filmed in tanks built inside a hangar at Long Beach Airport. A sixteen-foot-tall tank was used for longer shots, and a smaller, twelve-thousand-gallon tank was used for close-ups.

MIDWAY (1976)

Charlton Heston, Henry Fonda, James Coburn. Scenes were filmed at the U.S. Naval Station in Long Beach.

MIGHTY JOE YOUNG (1998)

Bill Paxton, Charlize Theron. For *Mighty Joe Young*, Disney had been shopping around for a location where it could build a carnival set dominated by a large Ferris wheel that would be set on fire and tipped over in a horrific ape-gone-amok scene. Long Beach turned out to be the go-to town, with a nice six-acre parcel of city land on the waterfront between the *Queen Mary* and the Queen's Way Bridge. Disney paid Long Beach $21,000 for use of the land. A big disappointment for set-watchers: The destruction of the full-size Ferris wheel was to have had the ride all aflame and crashing in a huge eruption of destruction. Instead, the crew just sort of tipped the thing over (it was on hinges), with all of the more spectacular effects being done later on a model.

Even so, the *Mighty Joe Young* carnival set on Queensway Bay lit up the skyline for a week. Film crews also provided a similarly spectacular sight in Seal Beach when they strung hundreds of light bulbs along the pier there to provide a romantic setting for a bit of on-the-strand dialogue between the film's stars, Theron and Paxton.

The crews also used a pair of giant light banks, which were elevated with hydraulics in the parking lots off Tenth and Eighth Streets, on either side of the pier, to provide a moonlight glow over the setting.

MODERN TIMES (1936)

Charlie Chaplin, Paulette Goddard. Harbor scenes were shot, with the Edison plant in the background, in the Port of Long Beach.

MONEYBALL (2011)

Brad Pitt, Robin Wright, Jonah Hill. Most baseball scenes were shot at Oakland Athletics Field in Oakland and Fenway Park in Boston, but Long Beach's Blair Field at Recreation Park did some relief work with some exterior shots in the parking lot and some spring-training scenes.

Charlie Chaplin visited Balboa Films three times during the studio's heyday and filmed part of his epic *Modern Times* in the harbor at Long Beach.

THE MOST DANGEROUS GAME (1932)

Joel McCrea, Fay Wray. This film included scenes shot in the harbor area.

MOVING VIOLATION (1976)

Stephen McHattie, Kay Lenz, Eddie Albert.

MOVING VIOLATIONS (1985)

John Murray, Jennifer Tilly. Parade scenes were filmed on Ocean Boulevard downtown and at First Street and Atlantic Avenue.

MR. & MRS. SMITH (2005)

Brad Pitt, Angelina Jolie. Filmers used the paved area on Pier S in the Port of Long Beach. John and Jane Smith (Pitt and Jolie) are chased by a team of assassins down the Terminal Island Freeway in Long Beach, playing the role of a New York City highway.

MULTIPLICITY (1996)

Michael Keaton, Andie MacDowell. Scenes were filmed aboard the *Queen Mary*.

THE MUSE (1999)

Albert Brooks, Sharon Stone. Scenes were filmed at the Aquarium of the Pacific shortly before it opened to the public.

A station wagon towing Koko the Clown crashed, as scripted, into newspaper racks on Atlantic Avenue at First Street in a scene from *Moving Violations*. *Courtesy of* Press-Telegram.

MY GIANT (1998)

Billy Crystal, Kathleen Quinlan, Gheorghe Muresan. Scenes were shot at St. Mary Medical Center.

NANCY DREW (2007)

Emma Roberts, Tate Donovan. Nancy's school, on the outside, is Hollywood High School, 1521 North Highland Avenue, in Hollywood. But most of the school interiors were filmed at Long Beach Poly High, 1600 Atlantic Avenue.

NATIONAL SECURITY (2003)

Martin Lawrence, Steve Zahn. Where there's a car chase, there's the Vincent Thomas Bridge, which pops up again here. Also, Earl (Lawrence) blows up a vehicle on Linden Avenue in the East Village.

THE NATURAL (1984)

Robert Redford, Robert Duvall, Glenn Close. The *Queen Mary*'s dining room played the part of ballplayer Roy Hobbs's hotel suite.

THE NEGOTIATOR (1998)

Samuel L. Jackson, Kevin Spacey. Long Beach took on the role of Chicago, with the El Dorado Park duck pond on Studebaker Road playing the part of a pond in a Chicago Park. Not much of a stretch. The only problem was that the shooting took place during mid-December, but the role called for a more summery scene, so the crew asked nearby residents on Studebaker to turn off their holiday decorations during nighttime filming.

THE NEW GUY (2002)

DJ Qualls, Lyle Lovett. Mostly filmed in Texas, some school scenes were shot at Poly High.

NEWSIES (1992)

Christian Bale, Bill Pullman, Robert Duvall. The Disney musical's first day of filming took place in downtown Long Beach, playing a Brooklyn scene.

NEXT (2007)

Nicolas Cage, Julianne Moore. The recently restored 1930s Long Beach Generating Station on Terminal Island can be seen in filming shot at the port.

A NIGHT IN COMPTON (2004)

Joshua David Brown, Tommy "Tiny" Lister.

1941 (1979)

John Belushi, Dan Aykroyd. Cal State Long Beach grad Steven Spielberg used Long Beach Airport for a scene of a press conference gone horribly wrong.

NIXON (1995)

Anthony Hopkins, Joan Allen, Powers Boothe. We haven't been to the White House, so we can't offer an opinion on how closely the entrance to the El Dorado duck pond on Studebaker Road resembles the approach to the White House, and we don't know what kind of fancy film work Oliver Stone had to do to gussy up the park for its Pennsylvania Avenue role. In the Long Beach scene, Nixon (Hopkins) is riding in his limo as it pulls out of the White House grounds, while a swarm of protesters wave signs and chant "Hell No! We won't go!"

THE NORTH AVENUE IRREGULARS (1979)

Edward Herrmann, Barbara Harris.

NORTH DALLAS FORTY (1979)

Nick Nolte, Mac Davis. In a bit of a stretch, the beautiful Long Beach baseball diamond played some scenes as a football field.

NOT ANOTHER TEEN MOVIE (2001)

Chyler Leigh, Jaime Pressly. In this spoof of *American Pie* and other teen comedies of the 1990s, the producers deliberately used the same setting as many of those movies so it would have the same look. Hence, the *American Pie/Ferris Bueller* neighborhood of Country Club Drive in Los Cerritos was used here as well.

NOTHING SACRED (1937)

Carole Lombard, Fredric March. Scenes were shot in the harbor area.

NURSE BETTY (2000)

Renée Zellweger, Morgan Freeman, Chris Rock. Scenes were filmed in Lakewood.

THE ODD COUPLE 2 (1998)

Jack Lemmon, Walter Matthau. While filming was taking place in Long Beach on this sequel, we wrote:

> *Before you decide to let Hollywood use your house for a feature film, consider what Paramount has done to the showpiece apartment in the beautiful old building next to the Long Beach Museum of Art on Ocean Boulevard.*
>
> *In short, they've trashed the place.*
>
> *"It looks like the Third World War has hit it," says Rita Bluemel, the daughter of the building's owner, Marie Koutunis.*
>
> *Of course, she means that in the good sense of a Third World War hitting it. Messy, after all, is the point. Paramount is using the Koutunis apartment for slob Oscar Madison's apartment/hovel in the upcoming feature film,* The Odd Couple 2: Travelin' Light, *starring, once again, Walter Matthau and Jack Lemmon.*

"Basically, we've just been messin' the place up," says location manager Jim Maceo.

Adds Bluemel, "It looks horrible. We'd recently painted the interior a pale yellow with white trim. Now they've repainted it a dark blue with peach trim. Of course, they'll restore it to the way we had it when they leave," she says. "They've been absolutely wonderful to work with. I was initially concerned, but they've been most accommodating, just super."

But then, it's not over yet. The production was supposed to have wrapped up filming at the building, which, in the movie, plays an apartment house in Sarasota, Florida. Instead, Lemmon missed a couple of days shooting in Long Beach when he was taken to Cedars-Sinai with an undisclosed illness, delaying the filming by a couple of days. By Thursday, though, he was back on the job, and the project was to have been wrapped up over the weekend, which filmed all over town, including Blair Field and a private residence on Ocean Boulevard.

THE OTHER SIDE OF THE MOUNTAIN (1975)

Marilyn Hassett, Beau Bridges. Veterans Administration Medical Center on Seventh Street was used for hospital scenes.

THE OTHER SISTER (1999)

Juliette Lewis, Diane Keaton. Long Beach's Poly High took on the role of an East Coast tech school. Film crews shot inside classrooms (after class, of course) as well as all around the grounds during a five-day stay at Poly.

OUT TO SEA (1997)

Jack Lemmon, Walter Matthau. Scenes were filmed aboard the *Queen Mary*.

THE PARENT TRAP (1998)

Lindsay Lohan, Dennis Quaid and Natasha Richardson. Disney's remake of its 1961 classic, featuring the young and innocent Lindsay Lohan in her first feature-film role, took Long Beach by land, air and by sea, shooting scenes in and around the *Queen Mary* and at Long Beach Airport.

PAULIE (1998)

Gena Rowlands, Tony Shalhoub, Cheech Marin. Long Beach's reputation in Hollywood as the "City of a Thousand Faces" continued apace in this film in which the city played a town in New Jersey. The Jersey performance wouldn't have been much of a stretch were it not for the fact that Long Beach was being asked to play the Jersey shore town in the middle of a Jersey winter. Long Beach doesn't do winter well.

Crews came to town to winterize the neighborhood around the intersection of Sixth Street and Newport Avenue by stripping all the leaves from the trees and covering streets, yards and houses with snow. The production also filmed some scenes on the Gerald Desmond Bridge.

PEARL HARBOR (2001)

Ben Affleck, Kate Beckinsale, Josh Hartnett. Rafe and Evelyn (Affleck and Beckinsale), out in a small boat at night in New York Harbor, float past the *Queen Mary* ocean liner. The filming took place at the *Queen*'s current home in Long Beach. In the movie, when Evelyn says she'd love to dance aboard the luxury ship, Rafe attempts to get them aboard but fails. However, the couple are seen dancing in a New York nightclub in the preceding scene, and that was filmed in the ship's Queen's Salon. This was noted by Gary Wayne of the fine website Seeing-Stars.com, who further observed, "For those in the know, it seems somewhat comical that Evelyn is pining about never getting aboard the big ship, when, in fact, they had just left it."

PERFECT (1985)

John Travolta, Jamie Lee Curtis. This is as close as we've managed to get to a big-screen appearance. This film begins in the features section of the old Press-Telegram Building on Sixth Street and Pine Avenue downtown. The opening scene shows Travolta as a loser obituary writer for a newspaper. For verisimilitude, the crews chose our desk for the failing writer to use. Several real-life reporters and editors can be seen scampering around in the background. We were out of town on assignment. Some of us work for a living. Later in the flick, Travolta's character gets a job at *Rolling Stone*, where he gets a different desk and the movie subsequently falls apart.

PERSONS UNKNOWN (1996)

Joe Mantegna, Kelly Lynch, Naomi Watts.

PHANTOM (2012)

Ed Harris, David Duchovny. The Soviet Foxtrot–class B-427 *Scorpion* submarine, on display next to the *Queen Mary*, was used in this Cold War thriller.

PHOENIX (1998)

Ray Liotta, Anthony LaPaglia, Daniel Baldwin. A rousing alley fight scene was filmed in the easement behind downtown's Blue Cafe on The Promenade. For the scene, rain machines were brought in to change the climate for a brawl, including actor Liotta, in the alleyway, at the foot of a stairwell that once led to the darkroom above Terry's Camera on Broadway.

"It's a very cool-looking area," said Blue Cafe co-owner Vince Jordan. "It's all brick back there, and it really looks great in a vintage sort of way. I've always pictured it as having some purpose. Whoever picked it out for filming did a great job, because it's a really cool location."

The same location was also used for a scene in *It's a Mad, Mad, Mad, Mad World*. Following the roughhousing behind the Blue, the crew and cast moved across town to an apartment complex on Carson Street in Bixby Knolls for some drive-up and drive-away shots. The filming caused a bit of a civic stir later when crew moved downtown and painted up the old Typewriter City front on Broadway at the Promenade to look like a cheap porn palace, bearing the words LIVE NUDE GIRLS on the outside in huge letters. Several residents called the police and city hall, fearing a relapse of downtown into Smutsville. The scenes using the building were shot late Wednesday night, and by Thursday afternoon, nude business was stripped from the building.

PIRATES OF THE CARIBBEAN: ON STRANGER TIDES (2011)

Johnny Depp, Penélope Cruz, Ian McShane. After filming in Hawaii, crews flew to Long Beach to film the ship *Providence* (played by San Diego–based HMS *Surprise*, a replica of the British frigate HMS *Rose*) in the waters off Long Beach. The ship was docked at Berth 45 in Long Beach.

PIRATES OF THE CARIBBEAN: THE CURSE OF THE BLACK PEARL

(2003)

Johnny Depp, Geoffrey Rush, Orlando Bloom. Commodore Norrington's (Jack Davenport) ship, the *Dauntless*, was constructed to resemble the British warship the *Victory*, a famous one-hundred-gun ship once the pride of the British fleet.

To create the ship, crews built sections of it on a barge docked at Pier C in Long Beach. At one point, 150 people worked on construction of the floating set, which took about three and a half months to build, rain or shine. According to the film's production notes, upon completion, the ship measured 170 feet long, 34 feet wide and consisted of approximately 40,000 pounds of steel and 1,000 square feet of sails. Seven cellphones, five men, three welding hoods, two dozen tape measures, one metal cutting saw and countless tools fell overboard during construction.

Fabrication of the *Black Pearl* in the Long Beach Dome next to the *Queen Mary* was a little tamer. The *Black Pearl* was filmed in sections, some on stage and some on a barge that was towed in open water. Often, the *Black Pearl* had a tugboat pulling it, which had to be painted out during the visual effects process.

PLEASANTVILLE (1998)

Tobey Maguire, Jeff Daniels, Joan Allen. Crews came a couple times to shoots scenes in the St. Anthony High School gym.

THE POSEIDON ADVENTURE (1972)

Gene Hackman, Ernest Borgnine, Shelley Winters. The Irwin Allen disaster epic has a lot of *Queen Mary* scenery, with mostly pre-disaster scenes shot in the Queen's Salon, the main dining room, the engine room and hallways of the ship. Plus, there are some great (for the time, anyway; now you could do it on your iPhone) effects, including the *Queen Mary* flipping over. Havoc ensues.

PRIEST (2011)

Paul Bettany, Cam Gigandet. A nicely junked-up abandoned gas plant near Orange Avenue and Spring Street in Signal Hill played the part of a latter-day Jericho in the vampire-slaying graphic novel adaptation.

PRIMAL FEAR (1996)

Richard Gere, Laura Linney, Edward Norton. A scene was filmed in the ballroom of the *Queen Mary*.

PRINCE OF DARKNESS (1987)

Donald Pleasence, Lisa Blount. Donald Pleasence (or perhaps his driver) got lost trying to find the abandoned ballroom used for a church scene on the first day of shooting in Long Beach in this John Carpenter film.

PRIVATE BENJAMIN (1980)

Goldie Hawn, Eileen Brennan.

RAISE YOUR VOICE (2004)

Hilary Duff, John Corbett, Rebecca De Mornay.

REDBELT (2008)

Chiwetel Ejiofor, Tim Allen. Written and directed by David Mamet, who shot many of the martial arts action sequences inside the Pyramid at Cal State Long Beach. Scenes were also filmed at the North Long Beach Art Deco landmark the Atlantic Theater.

RED CORNER (1997)

Richard Gere, Bai Ling. The oft-filmed Long Beach Airport goes deep again, this time representing an airport in Beijing, China. Both interiors and exteriors of the terminal, including the upstairs lounge and restaurant, were used.

RED DRAGON (2002)

Anthony Hopkins, Edward Norton, Ralph Fiennes. The Ferris Bueller House at 4160 Country Club Drive took on a decidedly more dramatic, if not macabre, role for the opening scenes in this prequel to *Silence of the Lambs.* The police find blood everywhere as they enter the house where Hannibal Lecter slaughtered a family.

RICHARD PRYOR: LIVE IN CONCERT (1979)

Richard Pryor. Regarded as the best example of the genius' stand-up act, the concert was filmed at the Terrace Theater, 300 East Ocean Boulevard.

THE RICH MAN'S WIFE (1996)

Halle Berry, Christopher McDonald. Scenes were filmed at the now-closed Foothill Club on Signal Hill.

RIFT (2011)

Leslie Easterbrook, Richmond Arquette.

THE ROAD HOME (ALSO KNOWN AS THE PITCHER AND THE PIN-UP) (2003)

Drew Johnson, David A. Burr.

Comic genius Richard Pryor gave one of his greatest stand-up performances at Long Beach's Terrace Theater. It was released as *Richard Pryor: Live in Concert* in 1979.

RoboCop (1987)

Peter Weller, Nancy Allen, Dan O'Herlihy. The old Ford complex on Henry Ford Avenue was used in an early scene.

The Rose (1979)

Bette Midler, Alan Bates. Midler plays a Janis Joplin-esque rock singer unable to deal with rampaging success in this movie, with a key scene shot onstage at Veterans Stadium in 1978. One Long Beacher recalled how "the immediate neighborhood was blanketed with invitations" for people to show up in the stands as extras for the concert. "People were encouraged to wear '60s attire, and the stands were packed with middle-aged 'hippies.' It was a really fun event, and the production company paid everyone fifteen dollars for attending."

RUN SILENT, RUN DEEP (1958)

Clark Gable, Burt Lancaster, Jack Warden. A reader recalled watching Clark Gable being filmed while trimming a tree at 3421 Ocean Boulevard.

"I remember this because my girlfriend's mom took us down there to watch, and we were able to see both Burt Lancaster and Clark Gable," he recalled. In one scene, the two are standing for several minutes on Ocean Boulevard at around the 3100 block with Bluff Park in the background.

RUSH HOUR 3 (2007)

Jackie Chan, Chris Tucker, Max von Sydow. Scenes were filmed at St. Mary Medical Center, 1050 Linden Avenue.

SAY IT ISN'T SO (2001)

Chris Klein, Heather Graham, Sally Field. The rain-drenched Long Beach Airport signed on to play the role of a small-town "Shelbyville Airport." The crew and some of the stars (Field was spotted by airport employees getting her hair done up in '50s fashion for the period piece) filmed all day in the rain.

THE SCOUT (1994)

Albert Brooks, Brendan Fraser. Scenes were shot at Blair Field at Recreation Park.

SEABISCUIT (2003)

Tobey Maguire, Jeff Bridges. Crews wrecked Anaheim Street between Long Beach Boulevard and Pine Avenue for a week, covering it with dirt and turning the stretch of road into something out of the pre-paved 1930s.

Nothing but rutted dirt and mud, not even one little blissful patch of asphalt anywhere. The Antique Automotive Museum at 205 Anaheim Street played a pair of pivotal parts in *Seabiscuit*. It served first as a San Francisco bicycle shop owned by Charles Howard (Bridges) and, later, as one of the West Coast's first auto dealerships, again owned by Howard.

THE SECRET ADMIRER (1985)

C. Thomas Howell, Lori Loughlin, Kelly Preston. The final scene was shot at the Port of Long Beach.

SENSELESS (1998)

Marlon Wayans, David Spade. Lakewood's Glacial Garden skating arena was borrowed for filming some hockey high jinks for this feature about a college student (Wayans) who dreams of success on Wall Street, undergoing a psychology experiment that goes awry, with one of the side-effects being that he's transformed from an inept hockey goaltender into a great one. Performing much of the goal-tending during the filming was "stuntman" NHL goaltender Grant Fuhr, a former L.A. King.

SCHOOL FOR SCOUNDRELS (2006)

Billy Bob Thornton, Jon Heder. Crew and talent—including Thornton and Heder (*Napoleon Dynamite*)—came to downtown's Madison restaurant on Pine Avenue to shoot a scene for the comedy. The scene shot at Madison involved the liberation of some doomed-to-supper lobsters. According to "our man" in Hollywood, a lobster wrangler was on the set and no live lobsters were harmed in the filming (though, presumably, eventually…). Rather, our man reports, rubber "stunt lobsters" were used for the more violent scenes.

SEMI-TOUGH (1977)

Burt Reynolds, Kris Kristofferson, Jill Clayburgh. Veterans Stadium on Clark Avenue was used for some pigskin scenery. Hundreds of extras were lured in from newspaper advertisements to watch the players. Vets showed its impressive acting range in the filming with half the field flooded and muddied up to represent Lambeau Field in Green Bay, while the other half remained dry, portraying Mile-High Stadium in Denver. Locker room scenes were also filmed at Vets.

SHOWDOWN IN LITTLE TOKYO (1991)

Dolph Lundgren, Brandon Lee. Downtown Broadway, between The Promenade and Long Beach Boulevard, was transformed into Little Tokyo for some scenes involving Lundgren.

SILENT RUNNING (1972)

Bruce Dern, Cliff Potts. The interiors of the space-age Valley Forge Space Freighter in this sci-fi flick were actually filmed inside the USS *Valley Forge* aircraft carrier when it was dry-docked in the Long Beach Naval Shipyard to be dismantled.

S1mONE (2002)

Al Pacino, Catherine Keener.

SIX WEEKS (1982)

Dudley Moore, Mary Tyler Moore

Action actor Dolph Lundgren gets wired for sound before shooting a scene on Broadway between the Promenade and Long Beach Boulevard in 1991's *Showdown in Little Tokyo*. *Courtesy of* Press-Telegram.

SLEEPOVER (2004)

Alexa Vega, Mika Boorem. High school hallway scenes, always swell settings for teen drama, were filmed at Long Beach Poly High.

SLIP (2006)

Donald Turner, Hosea L. Simmons. Long Beach locations include the Vincent Thomas Bridge.

THE SLUMS OF BEVERLY HILLS (1998)

Natasha Lyonne, Alan Arkin. Scenes were filmed at Long Beach Airport.

THE SOLOIST (2009)

Scenes were filmed in the auditorium of Jordan High School in North Long Beach. When the book of the same title, on which the movie was based, was chosen as Long Beach Reads One Book in 2010, author Steve Lopez gave a reading at the high school.

SOMEONE TO WATCH OVER ME (1987)

Tom Berenger, Mimi Rogers. Scenes were shot aboard the *Queen Mary*.

SPACE JAM (1996)

Michael Jordan, Wayne Knight. Long Beach proved to be a better two-sport athlete than the star of this comedy. The baseball scenes were shot at Blair Field (we attended the shooting; Jordan did a great job portraying a guy who couldn't hit a curveball), while basketball scenes were filmed at the Long Beach Arena. Additional scenes were filmed at the Pyramid at Cal State Long Beach.

SPEED (1994)

Keanu Reeves, Dennis Hopper, Sandra Bullock. Although the real star of the show, in terms of concrete, was the yet-to-open Century Freeway, Long Beach pitched in with some speedy scenes along Ocean Boulevard. The bus grabs the Shoreline Drive exit from the Long Beach Freeway (check the Hilton Hotel on your left) and goes east (sometimes in the wrong lane!) past Linden Avenue.

SPIDERS II: BREEDING GROUND (2001)

Stephanie Niznik, Greg Cromer. Arachnidmania at Long Beach Airport!

SPRING BREAKDOWN (2009)

Amy Poehler, Parker Posey, Rachel Dratch. Who do you call when you need a stand-in for South Padre Island in Texas for a Spring Break flick? Mothers Beach in Long Beach.

SPY HARD (1996)

Leslie Nielsen, Nicollette Sheridan, Charles Durning.

STARGATE (1994)

Kurt Russell, James Spader. Filming was done on a soundstage in the Queen Mary Dome.

STARSHIP TROOPERS (1997)

Casper Van Dien, Denise Richards. A futuristic indoor football game was filmed at the Pyramid at Cal State Long Beach.

STARSKY & HUTCH (2004)

Ben Stiller, Owen Wilson, Snoop Dogg.

Film crews begin work outside city hall for the filming of a scene from 2009's *Star Trek*. The city council chambers were borrowed to portray the Starfleet Academy Assembly Hall. *Thomas Wasper.*

STAR TREK (2009)

Chris Pine, Zachary Quinto, Simon Pegg. Hollywood typically likes to keep mum about its projects in town, something that makes our life difficult at times, which is maddening, because we strive to make our life difficulty-free. When we showed up at city hall one brisk morning to find it all yellow-taped off and swarming with film crews, we had to spend the better part of a day to find out what the project was, though we'd been tipped off that it was *Star Trek*.

When quizzed about the project going on all around him, a city hall spokesman gave us a mountain of monosyllabic negative responses that all seemed to indicate that he didn't have the slightest idea of why a platoon of men, and the occasional woman, were busily shuttling from the fleet of trucks on Ocean to the civic center, to construct a web of scaffolding all around the perimeter of the building for which the spokesman was glancingly speaking.

A spokeswoman for the city's office, which deals with filming in Long Beach, told us the permit for the city hall project was issued for a movie called "Untitled Feature Film." When asked if she was at all curious about the film's actual title, she replied, "No. If I don't know the name of the film, I don't have to tell anyone what it is."

A Long Beach Police Department officer at the site told us, "It's some kind of space thing," which was the closest to the truth we got all day.

Crew members and security people were fairly unanimous in telling us that they were working on a film called *Corporate Headquarters*, which is not only a lame fake title—it sounds like something that should star Dennis Quaid and a dog—but it's also one they should change every once in a while if they want to keep things under wraps, because a Google search of "corporate headquarters" and "star trek" buried us in news about the code-named *Trek* flick and all manner of related gossip, but the underlying fact seemed to be that "Corporate Headquarters" is *Star Trek*. No Quaid. No dog.

Further, we found a casting-call site that had issued a quest for, among other types, "characters whose eyebrows will be shaved…to portray a 'Vulcan type' eyebrow shape," a description changed in later posts to "science-fiction type eyebrow shape."

Long story belatedly short: The 1976-retro-space-agey city hall building houses the city council chambers which were used for the Starfleet Academy Assembly Hall. Exteriors for the hall were filmed at a building on the Cal State Northridge campus. The Long Beach Generating Station on Terminal Island played an engine room in the movie.

STATE OF PLAY (2009)

Russell Crowe, Rachel McAdams, Ben Affleck. Scenes were shot at St. Mary Medical Center.

STEP BROTHERS (2008)

Will Ferrell, John C. Reilly: The boys wreck a boat on the west side of Parkers' Lighthouse in Shoreline Village.

A STOLEN LIFE (1946)

Bette Davis, Glenn Ford. Filmed mostly on the Warner Bros. lot in Burbank, a road trip was taken to shoot scenes of Davis meeting her cousin at Long Beach Airport while she is pretending to be her twin sister.

STOP! OR MY MOM WILL SHOOT (1992)

Sylvester Stallone, Estelle Getty.

STRIKE ME PINK (1936)

Eddie Cantor, Ethel Merman. Cantor stars as the operator of an amusement park, overrun by mobsters, called Dreamland. The park scenes, including a long and hilarious chase scene on the Cyclone Racer, were shot at the Pike.

SUGAR DADDIES (1927)

Stan Laurel, Oliver Hardy. This brisk pre-talkie short winds up with a romp through the Fun House at the Pike.

SUICIDE KINGS (1997)

Christopher Walken, Denis Leary.

SURF II (1984)

Eddie Deezen, Morgan Paull. Scenes in Long Beach include shots of a guy surfing on a VW on First Street between Orange and Cerritos avenues.

Left: Eddie Cantor starred as the operator of an amusement park, overrun by mobsters, called Dreamland in 1936's *Strike Me Pink*. The park scenes, including a long and hilarious chase scene on the Cyclone Racer, were filmed at the Pike.

Below: In a beach town without surf, you catch whatever you can get. In this case, a surfer gets a nice ride atop a Volkswagen on First Street between Orange and Cerritos Avenues for a scene in 1984's *Surf II*. *Courtesy of* Press-Telegram.

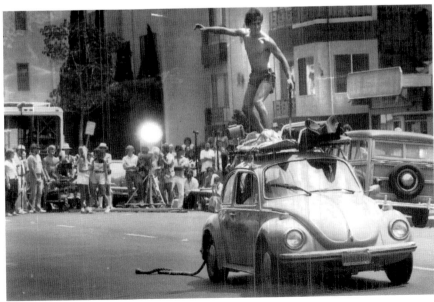

Laurel and Hardy teamed up with a romp through the Pike, including scenes in the Fun House, in the pre-talkie 1927 film *Sugar Daddies*.

SWING SHIFT (1984)

Goldie Hawn, Kurt Russell, Christine Lahti. Filmed mostly in San Pedro, there is a cycling scene in Long Beach, filmed long before the town was officially a bike-friendly city.

SWORDFISH (2001)

John Travolta, Hugh Jackman, Halle Berry. Scenes were filmed at St. Mary Medical Center.

TENACIOUS D IN THE PICK OF DESTINY (2006)

Jack Black, Kyle Gass. Scenes were filmed at Alex's Bar, 2913 East Anaheim Street.

TERMINATOR 3: THE RISE OF THE MACHINES (2003)

Arnold Schwarzenegger, Nick Stahl, Kristanna Loken. The scene in which Arnold takes John Connor to show him his mother's crypt (packed with weapons) is filmed at Rose Hills in Whittier, but when the Terminatrix shows up and things go sideways, we're suddenly at El Dorado Regional Park, north of Spring Street, all gussied up with headstones. The change in locale is presumably because a real cemetery wouldn't care much for the ensuing craziness, which includes a bullet-riddled hearse running over headstones and such. The following chase scene has the hearse making a turn, and suddenly we're in Griffith Park. A later scene takes place in the old Rockwell/Boeing NASA plant in Downey at 12214 Lakewood Boulevard.

TERMINATOR 2: JUDGMENT DAY (1991)

Arnold Schwarzenegger, Linda Hamilton, Edward Furlong. A huge nighttime multi-crash scene toward the end of the movie was filmed on the Los Angeles-Long Beach Terminal Island Freeway. The explosive segment included a helicopter crash and a tanker slide.

THELMA & LOUISE (1991)

Susan Sarandon, Geena Davis. The Cowboy Country/Silver Bullet Saloon, 3321 South Street, played the bar where the attempted rape that eventually leads to their adventure took place.

THERE WILL BE BLOOD (2007)

Daniel Day-Lewis, Paul Dano. Daniel Day-Lewis stakes his oil claim at oil-rich Spring Street and Orange Avenue. The movie is based (rather loosely) on Upton Sinclair's *Oil!*, which the author wrote while living in Long Beach.

THE THIRTEENTH FLOOR (1999)

Craig Bierko, Gretchen Mol. Scenes were filmed at the *Queen Mary*.

THREE DAYS OF RAIN (2002)

Penelope Allen, Erick Avari.

TIN CUP (1996)

Kevin Costner, Rene Russo, Don Johnson. El Dorado Park took a turn as a North Carolina golf course.

TITANIC (1997)

Leonardo DiCaprio, Kate Winslet. Scenes were filmed at the Belmont Plaza Olympic Pool by the Long Beach Pier.

TO GILLIAN ON HER 37TH BIRTHDAY (1996)

Peter Gallagher, Michelle Pfeiffer. Although the movie was largely filmed on location in Nantucket, Massachusetts, some beach scenes were filmed in Long Beach.

TO LIVE AND DIE IN L.A. (1985)

You get a nice bungee-jumping scene from the Vincent Thomas Bridge (which is also used prominently several times in the film), nice views of the harbor and a visit to the old Shipwreck Joey's topless bar in Wilmington.

TORQUE (2004)

Martin Henderson, Ice Cube, Monet Mazur.

TRANSFORMERS (2007)

Shia LaBeouf, Megan Fox, Josh Duhamel. After Sam's (LaBeouf) home is raided by the highly secretive Sector 7, Sam and Mikaela (Fox) are rescued by autobots next to a rail bridge over the Dominguez Channel along Pier A Avenue at the Terminal Island Freeway.

TRANSFORMERS: DARK OF THE MOON (2011)

Shia LaBeouf, Rosie Huntington-Whiteley: This time out, director Michael Bay made use of exteriors and upper-floor interiors at the rarely filmed Main Post Office on Long Beach Boulevard at Third Street in downtown.

TRANSFORMERS: REVENGE OF THE FALLEN (2009)

Shia LaBeouf, Megan Fox, Josh Duhamel. Shoreline Drive and the Queensway Bridge in Long Beach took on a role as a freeway in Shanghai. Downtown residents and businesses were given the heads-up regarding explosions, car chases, gunshots and the usual racket that accompanies director Michael Bay's works (*The Island, The Rock, Armageddon, Transformers*).

As usual, crews tried to keep things under wraps, a task made exceedingly difficult for them, as it turned out, because they were filming, unbeknownst to them, right outside our office windows, where the newspaper's excellent videographer/blogger Robert Meeks captured a nice chunk of it, including scenes of the yet-to-be-introduced Chevy Volt in a clip that went crazy viral on the Internet.

Crews driving in from out of town followed the cryptic but hardly secret anymore "E7" or "E72" signs to the base camps. "E7" was reportedly the production name given to the then secret *Transformers* film before it was released in July 2007.

Filming for *Transformers 2* went on for ten days on Shoreline Drive, the oft-filmed stretch of road that saw *Iron Man* wreaking havoc on the same stretch for a couple of weeks in April 2007.

TRIPPIN' (1999)

Deon Richmond, Donald Faison. The schoolin' scenes were shot at Narbonne High in Harbor City, but additional trippin' took place aboard the *Queen Mary*.

TRUE CONFESSIONS (1981)

Robert De Niro, Robert Duvall, Charles Durning. Scenes were shot at Joe Jost's Tavern on Anaheim Street. It was the first feature film to use that frequently filmed watering hole.

UNDER THE RAINBOW (1981)

Chevy Chase, Carrie Fisher. Filming was done at the *Queen Mary*.

THE USUAL SUSPECTS (1995)

Kevin Spacey, Gabriel Byrne, Chazz Palminteri. Mostly filmed in San Pedro (including at the Korean Friendship Bell), but some scenes shot in and around the Port of Long Beach.

VANILLA SKY (2001)

Tom Cruise, Penélope Cruz, Cameron Diaz. Long Beach Diaz and the others were filmed in the Queen Mary Dome.

VICE SQUAD (1953)

Edward G. Robinson, Paulette Goddard.

VIRTUOSITY (1995)

Denzel Washington, Russell Crowe. Filming was done in the Queen Mary Dome.

VIVA KNIEVEL! (1997)

Evel Knievel, Gene Kelly, Lauren Hutton. On the second day of shooting, when his first line of the day was to be, "I'm tired," Knievel told a reporter, "I really am. Actors can fake that stuff. I stayed up until 6 a.m. drinking tequila. That's my method acting." The movie features motorcycle stunts performed at Vets Stadium on Clark Avenue—including one in which the stuntman warns the kids of Long Beach to stay off narcotics "or you'll blow all to hell!"

V.I. WARSHAWSKI (1991)

Kathleen Turner, Jay O. Sanders, Charles Durning.

VOYAGER (1991)

Sam Shepard, Julie Delpy. Scenes were shot aboard the *Queen Mary*.

WARGAMES (1983)

Matthew Broderick, Ally Sheedy: Broderick meets with fellow techno-geeks at the still fledgling computer lab at Cal State Long Beach.

W.C. FIELDS AND ME (1976)

Rod Steiger, Valerie Perrine. Scenes were filmed aboard the *Queen Mary*.

WHAT LIES BENEATH (2000)

Harrison Ford, Michelle Pfeiffer. The Queen Mary Dome was used for filming.

WHAT WOMEN WANT (2000)

Mel Gibson, Helen Hunt, Marisa Tomei. Filmed aboard the *Queen Mary*.

WHO'S THAT GIRL (1987)

Madonna, Griffin Dunne. Originally called *Slammer*, filming for this Razzie Award–winning worst picture featured a scene with Madonna in the old Long Beach Plaza.

WIN A DATE WITH TAD HAMILTON (2004)

Kate Bosworth, Josh Duhamel, Topher Grace. Scenes were shot at Joe Jost's on Anaheim Street. The tavern was renamed The Little Dickens in the film.

THE WRECK OF THE MARY DEARE (1959)

Gary Cooper, Charlton Heston.

X (1963)

Ray Milland, Diana Van der Vlis. Also known as The Man with X-Ray Eyes, this Roger Corman movie is another film that made great use of the old Pike. The local scene featured Ray Milland and a young Don Rickles as a scheming carnival barker attending to a young woman who fell off a thrill ride.

THE X-FILES (1993)

When the filmers came to Long Beach, the movie's producers code-named the project "Blackwood" to keep the thing under wraps to prevent hordes of avid fans from descending on the set and screwing things up.

This "Blackwood" thing was scheduled to shoot for a couple of days at the popular bar/film set Joe Jost's, but that deal was scotched. Still, "Blackwood" was in town for a couple days to film some interior hospital scenes at St. Mary Medical Center. So, what was the big mystery behind "Blackwood"?

Our secret source, fearing for his very career, said the movie production was keeping a low profile because of its two stars, who are often hounded by what some may term overly geeky fans. Those two stars, said our source, "can be seen Sunday nights at nine on Fox."

This, of course, meant nothing to us. So we asked "our man" in Hollywood.

"If you were to call this movie 'The "Something" Files: The Movie,' you might be correct." We started to catch on.

A St. Mary spokeswoman told us that one scene was interrupted mid-shoot when the hospital's morning prayer went out over the loudspeakers, whereupon star David Duchovny leapt from his hospital bed and yelled, "I'm healed!"

ZODIAC (2007)

Jake Gyllenhaal, Robert Downey Jr.

Chapter 5

FILM STARS

THE LONG BEACH CONNECTION

This is a list of some of the notable stars of films with a strong Long Beach association.

FATTY ARBUCKLE

Roscoe Conkling Arbuckle was born in Smith Center, Kansas, on March 24, 1887, weighing fourteen pounds. The following year, the family moved to California, and by thirteen, Arbuckle had begun his vaudeville comic career. By the time he was twenty-one, the baby-faced funnyman was locally famous, singing and acting around Long Beach's Pike amusement zone.

In 1908, he met a young actress named Minta Durfee, and before a full house at the Byde-a-Wyle Theater next to the opulent Hotel Virginia on Ocean Boulevard, the couple was married by Long Beach mayor C.H. Windham.

At Long Beach's huge and prestigious Balboa Studios at Sixth Street and Alamitos Avenue, Arbuckle was already a true superstar, lured out here from New York. In Long Beach, he appeared in several films during the 1920s, including *A Travelling Salesman*, *Gasoline Gus* and the first movie version of *Brewster's Millions*.

Arbuckle spent lavishly; he purchased a $25,000 silver-trimmed touring car and a mansion on the 1800 block of Ocean Boulevard, where he was a neighbor of silent movie star Theda Bara. A tunnel extended from his

property down to the beach, and at night, he would run his horses up and down the surf line in the moonlight.

On September 5, 1921, after too much work and a painful separation from his wife, Arbuckle, who had also suffered burns as a result of a filming accident, took a break and drove to San Francisco with two friends for a stay at the St. Francis Hotel. They rented a party room and invited several women to the suite. One of the guests, Virginia Rappe, was hurt during the party and subsequently died of peritonitis caused by a ruptured bladder. Rappe's friend accused Arbuckle of rape, and though doctors found no evidence of rape, murder charges were filed. The resulting trial was one of the most spectacular news events of the decade, thanks in no small part to William Randolph Hearst's sensationalized coverage. After three trials, Arbuckle was found not guilty, but his career was ruined. He died June 29, 1933.

THEDA BARA

Born in Cincinnati in 1885, Bara was already famous by the time she showed up in Long Beach, buying a mansion on Ocean Boulevard next to the home of Fatty Arbuckle and near the residence of the owner of Balboa Studios.

One of the first sex symbols of the silent era—and, therefore, of filmmaking—Bara worked in Long Beach during the busy days of filming in town. Long before Elizabeth Taylor made a wreck out of *Cleopatra*, Bara played the role in the pre-talkies version, filmed just west of town on the Dominguez Slough. Long

Silent film star Theda Bara had a summer cottage on Ocean Boulevard next to Fatty Arbuckle's. She starred in *Cleopatra*, filmed outside of Long Beach in the Dominguez Slough. *Courtesy of* Press-Telegram *archives.*

Beach, being a dry town in those days, was quiet at night, even on the star-studded Ocean Boulevard. Bara and others in the biz tended to head south to Seal Beach for their partying in those days. The star died in 1955.

Barbara Britton

Born September 26, 1920, in Long Beach, the spectacularly lovely Barbara Britton (Barbara Brantingham) attended Poly High School and Long Beach City College and, as a teenager, represented Long Beach on the city's Rose Parade float. When the parade picture was printed in the paper, it drew the attention of a talent scout, and she signed a contract with Paramount Pictures. She made a string of more than twenty-five films during the 1940s and had a two-season stint in the 1950s as the amateur sleuth Pamela North in TV's *Mr. and Mrs. North*. Mostly, Britton was known for her lengthy tenure as a spokeswoman for Revlon. In the 1950s, when Long Beach's eastside developer Lloyd Whaley was selling homes in his Los Altos tract, he promised Britton he'd name a street after her in exchange for a local appearance on behalf of his project. Britton Drive runs along the south side of the Los Altos shopping center. In the 1970s, Britton had a role in the daytime soap *One Life to Live*. She died of pancreatic cancer in New York City on January 17, 1980.

Nicolas Cage

Certainly one of Long Beach's most celebrated and successful former citizens, Cage has appeared in more than sixty films—with more on the way—and won an Oscar and a Golden Globe for Best Actor in 1996's *Leaving Las Vegas*. Cage was born in Long Beach on January 7, 1964, and grew up on Hackett Avenue in the Los Altos area. Cage didn't blunder into show business; it was something he always wanted to do. One of his favorite hobbies growing up was staging plays in the neighborhood. To pursue his career, he left Long Beach. He told the *Press-Telegram* in 1998:

> *I thought the move would probably be better for me if I was going to try to get into the movie business. But going back to Long Beach for a visit recently, I'm not sure if my life is better now. If I'd stayed in Long Beach and done*

something else that didn't force me to be in Los Angeles proper because of the industry, I might have been happy in another way. I think Long Beach is kind of a wonderful place to grow up...It has the sense of a city, but at the same time, it's more rural, more suburban...I seem to always remember the light falling in Long Beach in a way that made everything glow, especially as a child playing in the backyard. I saw that light in Santa Fe, New Mexico, and also one place in Africa and, oddly enough, in Long Beach. The sunlight hits the trees the same way.

Cage has come to Long Beach a few times to work, including the filming of *Gone in Sixty Seconds* and *8mm*.

GEORGE CHAKIRIS

Another local Oscar award–winner, Chakiris earned his Academy Award for Best Supporting Actor for his role as Bernardo in 1961's *West Side Story*. Chakiris's family moved to a home on Grand Avenue near the Belmont Pier in Long Beach when George was twelve. He recalled in a 1995 *Press-Telegram* interview that he would occasionally ditch school at Wilson to watch a movie downtown and then walk down the beach back to the pier. As a member of St. Luke's Episcopal Church's choir, he sang in three movies, including *Song of Love*, with Katharine Hepburn. After a semester at Long Beach City College, Chakiris moved to Hollywood, but he kept in touch with the folks back home. In 1996, he co-starred with Lee Meriwether in the Long Beach Civic Light Opera production of *The King and I*.

LARAINE DAY

Born Laraine Johnson in 1917 in Roosevelt, Utah, she moved with her family to Long Beach, where she graduated from Long Beach Poly High in 1938. Laraine was a member of the Long Beach Players, where Robert Mitchum also learned the acting trade. The young actress took the screen name Laraine Day in honor of Elias Day, the longtime director of the Long Beach Players Guild. She was discovered by Hollywood talent scouts during one of the Long Beach production, and in 1937, she appeared in her first film with a bit part in King Vidor's classic melodrama

Poly High graduate Laraine Day came up with the Long Beach Players before going on to work in TV and film, including a star role in Alfred Hitchcock's *Foreign Correspondent. Courtesy of* Press-Telegram *archives.*

Stella Dallas. Subsequently, she took on several lead roles in a series of George O'Brian "B" westerns before hitting her feature-film peak as the leading lady, co-starring with Joel McCrea in Alfred Hitchcock's *Foreign Correspondent* in 1940. With the advent of television, she played several roles on the small screen, most memorably as Nurse Lamont in the medical drama *Dr. Kildare.* Sports fans will know Day for her thirteen-year marriage to baseball manager Leo Durocher. She took such an active interest in her husband's career and the sport in general that she became known as the "First Lady of Baseball."

BO DEREK

Bo Derek was born (as Mary Cathleen Collins) in Long Beach on November 20, 1956, and grew up in Torrance and Redondo Beach, where she spent most of her time in the water, either scuba diving, sailing or surfing. "I wasn't very big on school, so I didn't go very often," she told the *Press-Telegram* in 2000. She was big on the movies, though, at least for a while. Her most memorable role, of course, was as the woman of Dudley Moore's dreams in the hit movie *10.* Her film successes, which include *Tarzan, the Ape Man, Bolero* and *Tommy Boy,* came under the direction of her husband, John Derek, to whom she was married until his death in 1998.

CAMERON DIAZ

One of the most recognizable of all Long Beach exports, Cameron Diaz was born in San Diego in 1972 and raised in Long Beach, where she attended Poly High School. She claims to have been a shy and unpopular student at Poly. That all changed when she turned sixteen, when she scored a modeling contract with the prestigious Elite agency, who signed her to do worldwide work for Calvin Klein, Levi's and others. Diaz parlayed that success into a movie career that launched with a huge success opposite Jim Carrey in *The Mask*. Since then, she has compiled an amazing resume, with appearances in such hits as the *Charlie's Angels* franchise, *There's Something About Mary* and *Bad Teacher*. In an interview with the *Press-Telegram*, she said, "Sometimes I wonder, why me? I'm a firm believer that everything happens for a reason, and I really feel that there is some destiny involved in me getting these opportunities."

SNOOP DOGG

Born October 20, 1971, in Long Beach, Snoop's (Calvin Broadus) career has been mainly in music. At Long Beach Poly High, he met and hung out with Nathaniel Hale (the late Nate Dogg) and Warren Griffin III (Warren G) and others and began a new wave of rap and hip-hop. Snoop did make some appearances in feature films, though, most notably as Huggy Bear in 2004's *Starsky & Hutch*.

JOHN DYKSTRA

One of the heaviest hitters in motion-picture special effects, Dykstra, who was born in Long Beach in 1947 and grew up in Alamitos Heights and graduated from Cal State Long Beach, is responsible for some of Hollywood's most memorable FX scenes, including the opening images of the first *Star Wars* movie with the gigantic spacecraft slowly passing over the camera. For his work on that movie, Dykstra shared an Oscar for best visual effects. Since then, he has worked in visual effects for the *Spider-Man* and *Batman* films.

Film Stars

Clark Gable and Carole Lombard

The wildly famous Hollywood couple sailed on the *Queen Mary*, but that's only a tenuous Long Beach connection. Gable and Lombard, who were constantly hounded by the celebrity press long before there was an Italian name for the relentless photographers or a dozen and a half TV shows devoted solely to the pursuit of celebrity, had an apartment on Ocean Boulevard that they reportedly visited in the 1930s and '40s as a hideaway. In the 1980s, the *Press-Telegram* reported that there were rumors that the ghost of Gable was seen by its residents, who claimed they saw the star of *Gone With the Wind* wandering about sporting tousled hair and a three-day growth of beard. Lombard and Gable also summered at a beautiful Bluff Park home, now known as Weathering Heights, at 3065 East Ocean Boulevard—a home also rented by W.C. Fields for a summer shack.

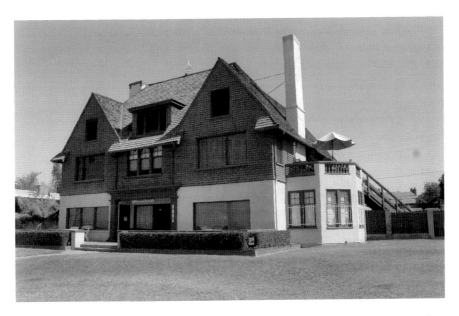

Clark Gable and Carole Lombard kept an apartment in Long Beach for getaways from the ever-hounding press in the 1930s and '40s. The star couple also summered at a beautiful Bluff Park home, known as Weathering Heights, at 3065 East Ocean Boulevard—a home also rented by W.C. Fields for a summer shack. *Hannah Grobaty.*

VAN HEFLIN

One of motion picture's most enduring character actors, Van Heflin appeared in forty-six movies and won an Oscar in 1942 for his supporting role as a newspaperman in *Johnny Eager*. Born Emmet Evan Heflin in Oklahoma in 1911, he grew up in Long Beach and attended local schools, including Long Beach Poly High, where his drama instructor suggested he become a lawyer. Throughout a long and successful career in Hollywood—his big-screen work included *Shane* and *My Son John*—he never cut his ties with Long Beach. In 1951, he attended Poly High's twenty-fifth reunion. Heflin died in 1971 at the age of sixty.

WALTER HILL

Tough-guy screenwriter, director and producer whose works include *Aliens, 48 Hrs., The Warrior* and *Red Heat* was born in Long Beach on January 10, 1942. His father was a riveter for a local shipbuilding company, and the young Walter spent his teens working as a roustabout in the Signal Hill oil fields before trying his hand at art. He studied for a while in Mexico before enrolling at Michigan State University, where he received a degree in journalism. His attention then shifted to filmmaking, so he headed back to California and scored his first credits as an assistant director on *The Thomas Crowne Affair* and *Take the Money and Run*. In television, he won Emmys for his directing work for the series *Broken Trail* and HBO's *Deadwood*.

JAMES HILTON

Born in 1900, British novelist James Hilton enjoyed a quiet and prosperous life in Walthamstow, England, for much of his life, writing a pair of best-selling and enduring novels, *Lost Horizon* and *Goodbye, Mr. Chips*. Soon, Hollywood called, and Hilton crossed the pond to become one of filmdom's highest-paid screenwriters, winning an Oscar for his work on the wartime weeper *Mrs. Miniver*. Hilton liked the money, but he wasn't nuts about the town. He spent his last ten years living and writing quietly at his modest home on Argonne Avenue in Belmont Shore until his death at Seaside Hospital in 1954.

SALLY KELLERMAN

The original, big-screen Margaret "Hot Lips" Houlihan of *MASH* was born in Long Beach on June 2, 1937, though she lived in her teens in L.A. and attended Hollywood High. After her success in *MASH*, she worked a few more times with that film's director, appearing in his *The Player* and *Pret-a-Porter*. Kellerman returned close to her birthplace in 2001 when she appeared in a cabaret series at the Orange County Performing Arts Center. When she lived in Long Beach, she told the *Press-Telegram* prior to the Orange County performance, "It seems right that I should be singing somewhere I know so well." Lately, Kellerman has been working in television, with continuing roles in the series *Chemistry* and *Unsupervised*.

DEFOREST KELLEY

Kelley was born in Toccoa, Georgia, and served in World War II as an enlisted man in the Army Air Force, where he was assigned to the First Motion Picture Unit. Afterward, he moved to Long Beach to live with his uncle. He took a job mopping floors and later roughnecking for Richfield Oil during the day while spending his evenings working as an actor with the Long Beach Community Playhouse. He was eventually discovered by Hollywood talent scouts, with some little success, generally getting small roles as a tough guy, until, at the age of forty-six, he bagged the role as Dr. Leonard Horatio "Bones" McCoy in the original *Star Trek* TV series. Utterly typecast in that role, he made a good living in the subsequent *Star Trek* movies, as well as in appearances at *Star Trek* conventions. He died in Los Angeles in 1999.

CAMRYN MANHEIM

Born in New Jersey in 1961, Manheim grew up first in Peoria, Illinois, and then, from the age of eleven, in Long Beach, where she attended local schools, including Wilson High. She had something bigger in mind, though. She told a reporter that, while a student at Wilson, she talked to some jugglers at Renaissance Faire who told her that Santa Cruz was where it was at. "They

told me what a cool, hippie-dippy place it was and how I could fit in perfectly. They clearly dug their hometown. I couldn't imagine gushing about Peoria or Long Beach like that, so when it came time to choose a college, I followed my heart and took the advice of a bunch of crazy jugglers. After UC Santa Cruz, Manheim went on to a successful career in Hollywood. Though she's appeared in a number of feature films, including *The Bonfire of the Vanities* and *The Road to Wellville*, she's best known for her TV work, including her Emmy-winning role as Ellenor Frutt in *The Practice* and subsequent roles in the TV series *The Ghost Whisperer*, *The L Word* and *Harry's Law*.

STEVE MARTIN

Next to Steven Spielberg, perhaps, Steve Martin is the most notable show-biz personality to come out of Cal State Long Beach. Martin, commuting from Garden Grove, studied philosophy long enough to give him a sharp sense of the absurd, which marked his early stand-up comedy work and serves him well to this day. His CSULB work wasn't confined to the rigors of thought. He also played a mean banjo at the college. His ties to Long Beach were strengthened when he spent several weeks in town, mostly on downtown's Pine Avenue, where he did much of the filming for his 1999 movie *Bowfinger*.

ROBERT MITCHUM

A hard guy on the big screen, Mitchum wasn't a softie in real life, either. Born August 6, 1917, in Bridgeport, Connecticut, Mitchum hit the road at sixteen, riding the rails and taking on jobs such as engine-wiper on a freighter and as a ditch-digger. He had twenty-seven bouts as a professional fighter and busted out of jail in Savannah, Georgia, where he was being held on charges of vagrancy. He rejoined his family in Long Beach in 1936 and, at his sister's urging, became involved in the Players Guild, the forerunner of the Long Beach Community Playhouse. For money, he ghostwrote for an astrologer, worked as a drop-hammer operator for Lockheed and sold shoes. Finally, he was discovered by scouts in a Long Beach production and made his way to Hollywood, where he would eventually star in more than one

Robert Mitchum was discovered by scouts in a Long Beach Community Playhouse production and made his way to Hollywood, where he would eventually star in more than one hundred movies. *Courtesy of* Press-Telegram *archives.*

hundred movies, including *The Story of G.I. Joe*, *The Sundowners* and *Cape Fear*. Mitchum died in 1999. He was seventy-nine.

MICHELLE PHILLIPS

Born in Long Beach in 1945, Phillips bolted early, first for a five-year stay in Mexico with her family, then off on a modeling quest at age sixteen. In 1961, she met her soon-to-be husband John Phillips, and by 1965, she was a member of his group The Mamas and the Papas. When the band and her marriage broke up in 1971, she went into the acting business with a career that included roles in *Dillinger*, (for which she was nominated for a Golden Globe) *Shampoo* and *Valentino*. She eventually settled into a career in TV, most notably for her role as Anne Matheson Sumner in *Knots Landing*.

Paul Rodriguez

The Mexican-born American comic enrolled in Long Beach City College in 1975 after a tour of duty in the Air Force. "Those were great times," the LBCC Hall of Famer told a *Press-Telegram* reporter in 1994. "My friends and I used to hang out on Long Beach Boulevard, and we used to hang out on Daisy Avenue." Rodriguez enrolled at Cal State Long Beach, but he barely cracked the books before he auditioned for and got the starring role in *D.C. Cab*, with Mr. T, Irene Cara and Gary Busey. Since then he has appeared in several TV shows and feature films, including *Ali*, *Blood Work* and *A Cinderella Story*.

Steven Spielberg

Spielberg, a multiple-Academy Awards/Golden Globes winner and producer-director-writer on more than eighty films, earned his degree— in film and electronic arts, of all things—from Cal State Long Beach in 2002. The star of his class had dropped out of Cal State in 1969 to horse around in the movie business for a couple of decades before realizing the importance of a degree if he wanted to get anywhere. He re-enrolled at the university under a pseudonym and studied independently off-campus while maintaining contact with his professors via telephone and email. Among the requirements for his degree was a term paper, a prepared résumé and the completion of an internship in the film business. Spielberg did his internship at his own Dreamworks, presumably sorting his own mail and getting coffee and bagels for himself.

Michael Stuhlbarg

Born July 5, 1968, in Long Beach, Stuhbarg studied the living daylights out of acting. He graduated from The Juilliard School in New York and also studied his craft at UCLA, the Vilnius Conservatory in Lithuania, the British American Drama Academy at Oxford and the National Youth Theatre at the University of London. He also studied mime with Marcel Marceau at the World Centre. For all that, Stuhlbarg spent a decade with

various roles on the small screen. He exploded, finally, onto the big screen with his role as Larry Gopnik in the Coen Brothers' *A Serious Man*, earning him several honors, including a Golden Globe nomination as Best Actor. He has since appeared in the feature films *Hugo* and *Men in Black 3* and earned a Screen Actors Guild Best Acting award for his work in HBO's series *Boardwalk Empire*.

NORMA TALMADGE

Norma Talmadge.

Talmadge, one of the top stars of the silent era's Long Beach connection wasn't connected to Long Beach other than as a property owner—but what a property! She was the owner of the Long Beach landmark, the Villa Riviera, when it was still a hotel. Her husband, Joseph M. Schenk, of Twentieth Century-Fox purchased the building for Talmadge near the time of the Long Beach earthquake of 1933. She apparently grew bored with the bauble rather quickly, leaving the hotel after less than a year of ownership.

TIFFANI-AMBER THIESSEN

One of Long Beach's breakout show-biz kids, Thiessen was born in the city on January 23, 1974, and broke into the modeling game when she was eight. One of her first jobs was holding a Ken doll in TV ads for the Peaches &

Cream Barbie doll. In 1992, she starred in her first movie, *A Killer Among Friends*, but found greater success in TV. After a guest spot in *Married...With Children*, she landed a role as cheerleader Kelly Kapowski in the series *Saved by the Bell*. Later, she was cast as Valerie Malone in the hit series *Beverly Hills 90210*. More recently, she has been appearing regularly as Elizabeth Burke in the series *White Collar*.

MEG TILLY

Born in Long Beach on Valentine's Day, 1960, Meg Tilly (her equally famous actress sister Jennifer was born in Los Angeles, hence means nothing to us) made herself known to American audiences in her role as a prostitute for *Hill Street Blues*, before launching onto the big screen in *The Big Chill* and *Psycho II*. She won a Golden Globe and an Oscar nomination for her title role in *Agnes of God*.

JOHN WAYNE

What's wrong with the name Marion Michael Morrison? Not enough swagger? Hollywood for decades was big on changing names, so our Marion became John—John Wayne—or the Duke, as both he and his childhood pet Airedale terrier were called. Wayne was born in Iowa, but the family moved to California when he was young and lived all over the Southland, including, briefly, in Long Beach, where Wayne attended Poly High for a semester before attending Glendale High and, later, USC. After he hit the big, big time in Hollywood, Wayne made frequent visits to see his not-especially-doting mother, Mary, and his stepfather Sydney Preen at their home on La Verne Avenue in Belmont Shore. Old-time Shoreites recalled spending their childhood years peeking over the fence to get a gander at the star when he was in town. Wayne died in June 1979.

John Wayne attended Poly High briefly before graduating from Glendale High School and the University of Southern California. After he hit the big, big time in Hollywood, Wayne made frequent visits to see his mother, Mary, and his stepfather Sydney Preen at their home on La Verne Avenue in Belmont Shore. *Courtesy of Press-Telegram archives.*

LINDA WOOLVERTON

Woolverton grew up in the Naples area of Long Beach and graduated from Cal State Long Beach with a degree in theater arts in 1974. She moved to Los Angeles and languished for a while as a secretary in the children's programming division at CBS and, after writing some children's books in her spare time, graduated to scriptwriting for the *Berenstein Bears* animated series, where her work drew the attention of a Disney exec. She was hired to work on the screenplay for the Golden Globe winner and Oscar Best Picture nominee *Beauty and the Beast*, which she followed with the screenplay for *Homeward Bound: The Incredible Journey* and earned a co-writing credit for the colossal hit *The Lion King*.

CELESTE YARNALL

Celeste Yarnall is a renaissance gal, and that's more than just a goofy rhyme. Born in Long Beach on July 26, 1944, her acting credits include roles in such modern classics as *New Kind of Love*, with Paul Newman; *Under the Yum Yum Tree*, with Jack Lemmon; *Bob & Carol & Ted & Alice*; and 2006's *Star Trek: Of Gods and Men*. In her spare time, she's made a fortune in the commercial real estate business, become a championship Tonkinese cat breeder, hosted a radio show, earned her PhD in nutrition and written best-selling cat care books.

ANTHONY ZERBE

No alphabetical list can end elegantly without a Z, and Anthony Zerbe is our Omega man in this one. Born May 20, 1936, in Long Beach, he headed to Hollywood after graduating from Pomona College. His career, still going, has included more than fifty films, including *Cool Hand Luke, Papillion, How the West Was Won, The Matrix Reloaded, The Matrix Revolutions*—and, yes, *The Omega Man*.

Chapter 6

NOTES FROM THE FILM BEAT

Although this book is about feature filming in Long Beach, there's no way we can overlook the small-screen work that has used the city for settings. To be even semi-complete, it would take a bigger book than this, and it would include dozens of television series that used the town for multiple episodes.

While a big-ticket feature gives Long Beach its star power, television series pay the bills. Crews stay in town for weeks, sometimes months. Showtime's *Dexter* is the best example. Long Beach locals can't even turn on their imaginations and picture *Dexter* taking place anywhere but Long Beach. You see Mothers Beach, Shoreline Village, the Queensway Bridge, Alamitos Bay—even more inland parts of town where houses were used as several of the characters' residences. Anywhere there's a palm tree in Long Beach, you've seen it on *Dexter*.

Other series that have enjoyed extended stays in town include *True Blood*, *NCIS: Los Angeles*, *CSI: Miami* (second, perhaps, to *Dexter*), *Joan of Arcadia*, *Ally McBeal*, *Starsky & Hutch*, *The O.C.*, *TJ Hooker*, *Charlie's Angels* and *The X-Files*.

The SS *Minnow*, the ill-fated craft of Gilligan (played by Jordan High grad Bob Denver) and his crewmates was last seen—and shown in the opening credits—leaving the Alamitos Bay Marina for a three-hour cruise that extended into three seasons, with a workmanlike ninety-eight episodes.

One of the first stories we wrote for the paper was being on the set of *CHiPs*, where we saw stars Erik Estrada and Larry Wilcox as they sat astride

Above: Crews work with a segment of an airplane passenger compartment while filming a commercial for Honda at Long Beach Airport. *John Robinson/Long Beach Locations*

Left: William Shatner finds his motivation as a tough-as-nails police sergeant for a scene in *T.J. Hooker* filmed in 1984 at the old Long Beach Plaza downtown. *Courtesy of* Press-Telegram.

The stars of TV's *CHiPs*, Larry Wilcox (left) and Erik Estrada, sit astride their training-wheeled Kawasakis at the foot of Bixby Hill on Palo Verde Avenue. *Courtesy of* Press-Telegram.

trailered Kawasakis being towed behind the camera truck for a sequence showing them chatting with one another.

And this is to say nothing of TV commercials, the filming of which is an almost daily occurrence in Long Beach, especially car ads, thanks to its easy-to-close speedways along Shoreline Drive and the Queensway Bridge. Some of the better ones that we can recall were a Jack-in-the-Box ad filmed in the Los Altos area, featuring monkeys and a rocket ship; a man sitting on a bus bench talking to a chicken in an ad for Taco Bell filmed in the East Village; and a herd of real reindeer going off the script and battling it out, antlers a-flyin', for a Marshall's commercial downtown.

What follows is a collection of some of our columns over the past dozen years or so, in which we tried to keep our readers informed about movie-making in town—not always easy given the unflagging quest for secrecy among many makers of filmed productions in Long Beach. And we're not just talking about the big productions either that will sometimes draw crowds of curiosity-seekers (though that's never been a big problem in

Donner, Blitzen, Cupid and what appears to be Comet (could be Vixen) mix it up in some rough reindeer games in the East Village at a filming for an ad for Marshalls. *Thomas Wasper.*

Long Beach, where people have grown accustomed to the weirdest things happening). We've drawn the wrath and ire of makers of commercials, as well—especially when we give away the punch line, like the time we spilled the beans about the Jack in the Box monkeynauts. Lot of unhappiness over that one. We suppose the ad makers were afraid the competition was going to rush a monkey into space in time to beat them.

LONG BEACH RETURNS AS *DEXTER*TOWN

It is killing season in town. For five years, murder has peaked during the summer months. A look back at some "highlights" will show:

—A bloody body found on the rocks beneath the Queensway Bridge.

—Disembodied limbs found under a Christmas tree in Shoreline Village.

—A back room of an apartment across from Alamitos Bay, where a serial killer drains the blood from his victims by hanging their bodies upside down.

—A head found in Drake Park.

—A comic book guy's body found in a comic book store, again at Shoreline Village.

—A woman's body discovered in a bathtub full of blood in a nice neighborhood in the Plaza.

Happily, there's more to come as the filmers of *Dexter*, the bloody and wryly amusing Showtime smash hit series about a serial killer–killing serial killer police department blood-spatter expert, have returned to Long Beach, the scene of so many *Dexter* crimes, for another season's worth of filming.

And, lest our sparkling city's reputation for seaside crime-free living be tarnished, none of the above-mentioned grisly incidents have occurred in real-life Long Beach, but, rather, in fake-life Miami and its environs, a part of the country that Long Beach can play in its sleep. You want Mark Twain, you call up Hal Holbrook; you want Miami, you come to Long Beach.

CSI: Miami and plenty of other shows have dragged Miami into Long Beach, but none has done it as thoroughly as *Dexter*, which has used scores of locations in Long Beach for hundreds of scenes.

You can see the whole array of the city's work in the series in the studiously researched collection at Gary Wayne's www.seeing-stars.com, and there's more on the way.

Last week, *Dexter* crews began shooting the series' sixth episode in preparation for a fall premiere on the pay channel. Already in the can were some scenes filmed last week at the Gaslamp Restaurant on Pacific Coast Highway at Loynes Drive.

Crews were also at a preschool in Belmont Heights, which will reportedly be featured in a recurring role. Also finished are scenes shot this week at Wilson High School.

Coming up, look for some repeat visits from *Dexter* crews to a body shop on Signal Hill, which we suppose will be playing the role of Tulsa or, on a clear day, Wichita Falls, because Signal Hill just can't do Miami.

Our Man in Hollywood says we can expect to see *Dexter*-related mock mayhem through October.

—June 2, 2011

FILMING DAMPEND

All this rain is causing a drought in the local movie business, where Long Beach is a prime location noted for its 580 days of sunshine every year.

Look, when filmmakers want rain, they'll haul it in themselves, thank you. The natural version is just too phony looking and uncontrollable, so this unseasonal winter weather is not looked on happily by the business of show.

Plus, the rain comes on the heels of Christmas vacation, which, in the film industry, lasts well past Epiphany and on to Martin Luther King Jr. Day, which they also take off. So, there's not a lot to report for January, other than ABC's *FlashForward* using Blair Field last week.

But let's go back to the cinematic equivalent of the Ghost of Christmas Past and look at what filmed in Long Beach in the three weeks before the holidays. Footage of Big Town has made commercial-viewing fun again, and you can look for glimpses of our city in a half-dozen or so TV ads filmed here in December.

Taco Bell, which has shot commercials in town a few times already, was back, on Norwalk Boulevard, for a spot.

In other fast-food filming, El Pollo Loco used the similarly nonglitzy Long Beach Boulevard for a quick take.

Budweiser, the King of Super Bowl ads, reportedly filmed a couple of game-time commercials at the Long Beach Arena on December 3 and 4.

The oft-filmed Queensway Bridge played the elegant setting for Drive Time, a company specializing in selling used cars to people with bad credit.

Embattled Chrysler shot scenes over in the genteel serenity of Country Club Drive and nearby Los Cerritos Park.

General Mills filmed a commercial for one of its products at Wilson High, while the Poly High campus was used for a commercial for Texas Health Resources.

Long Beach went 0-for-feature-film during December but made big money on small-screen stuff.

The cash cow that is *CSI: Miami* made several stops in town, including an intriguing shot at the shuttered Jergens Trust tunnel. Other spots visited by the cast and crew were the Civic Center, Shoreline Park, Aquarium Way, Golden Shore and Dana Place on the Peninsula.

Another show in residency here, *Criminal Minds*, shot street scenes on Lido Lane, Appian Way, Marina Drive, Monrovia Avenue and at the Colorado Lagoon.

Comedy Central's "Tosh.0," comic Daniel Tosh's romp through the Internet, filmed a sequence at Blair Field.

Closer to home, if by "home" you mean the place where we work, makers of the soon-to-be FX hit *Justified* were up at our suite of offices on the ground and fourteenth (just above the twelfth) floors at the ARCO Towers

Alamitos Bay takes another turn as a Floridian waterway in an episode for frequent Long Beach filmers *Criminal Minds*. *John Robinson/Long Beach Locations.*

in December. At the time, the show was called *Lawman*, but that title was already taken by Steven Seagal for his A&E show, which no one watches because Steven Seagal is attached.

Justified, which also shot scenes on Linden Avenue in the East Village (which used a fake fruit stand; a variation on Chekhov's Gun demands that if a fruit stand appears in the first act, then it must be hit by a car in the third act) and on Long Beach Boulevard downtown, is due out in March on the FX channel. It stars Timothy Olyphant (*Deadwood*) as Deputy U.S. Marshal Raylan Givens, a rough-and-tumble old-school lawman who appears in several Elmore Leonard short stories and novels.

—*January 25, 2010*

DEXTER REDUX

On the heels of our recent column about *Dexter* filming in Long Beach came a half-dozen homeowners wanting to know how to go about getting their

homes in the pictures, and one woman had just finished reading the article when, she says, she was contacted by *Dexter* scouts asking was it OK if they used her building at 1106 Wardlow Road for filming on Thursday morning.

"Isn't that something?" asked the lady, who didn't leave her name on our phone machine.

Yes, it is, considering we've been trying to get our own verisimilitudinous Miami-style mid-century manse into show biz for a decade now, and here this woman more or less blunders into it. That really is something.

In fact, we seem to be the only sucker in town not making *Dexter* dough lately. If you can swing a cat in Long Beach without hitting a *Dexter* crew these days, you're not using enough cat.

Last month alone the Showtime series shot scenes in Long Beach on Nipomo Avenue in the Los Altos/Plaza area; the flood-control area in El Dorado Park East (on several occasions); the Long Beach City Tow Yard; on Locust Avenue; on Weston Place; on Redondo Avenue; and on First Street.

Dexter fans who attempted to follow our directions last week to Long Beach sites used in the filming of the show, as detailed and photographed by Gary Wayne for his sometimes overly popular site www.seeing-stars.com, couldn't

What's to explain? It's a rooster watching a guy eat breakfast on a bus bench on Linden Avenue in the East Village. Stuff like this happens all the time in Long Beach. *Thomas Wasper.*

access the site because of the tremendous volume of hits received by the celebrity-sighting site on the day of Michael Jackson's funeral.

"I had links added from CBS, CNN and *Access Hollywood*," he says. "Most were sending traffic to my pages about Forest Lawn Hollywood, on top of people just Googling about Jackson. The numbers went through the roof, my Web host overreacted and essentially pulled the plug."

It's back now (barring more celebrity calamity, of course). Go to "locations" from the main menu, and click your way to *Dexter*.

Overlooked in our over-*Dexter*-ous coverage were some other roles Long Beach played last month.

—Crews and talent for A&E's *Gene Simmons Family Jewels* were aboard the *Queen Mary* June 8.

—Cast and crew for NBC's *Monk* were down at the Shore on Prospect Avenue and at Olympic Plaza June 16.

—Another sanguine cable TV series, HBO's *True Blood* filmed exteriors along Anaheim Street June 16.

—In the ad biz, Best Buy crews were at Veterans Stadium June 24, 25 and 29 with a crowd of 350 blue-shirted "employees" who were computerized into a full house at the stadium on Clark Avenue; Allstate shot an insurance ad on Fourth Street on June 4; and Taco Bell crews and talent (including a rooster) filmed June 25 at Broadway and Linden in the East Village.

—July 14, 2009

Up for the Kickoff

The lights were bright on Sunday night and Veterans Stadium was doing what it does best, doing what it was built to do: hosting a football game.

But, of course, this is Long Beach, the real Tinseltown, and nothing is what it seems. Cue the *Twilight Zone* ditty.

You could have been strolling along the shore of Alamitos Bay and seen grizzled and profoundly hungover Billy Bob Thornton tending bar, or you might've stumbled onto Jack Nicholson getting romantic with Helen Hunt at Khoury's or maybe you've hightailed it in terror after seeing Mr. T shooting Snickers bars out of a tank in El Dorado Park. That's all happened but not in real life.

You see things like that, and it doesn't mean anything other than film crews are here, using Long Beach as filmdom's favorite gigantic soundstage and set.

So, yes, there was football going on at Vets Stadium on Sunday, but, this being the exact halfway point of the baseball season, it wasn't a real game. Rather, it was a commercial for Samsung, presumably getting suited up for the fall football season.

Veterans Stadium has a pretty handsome resume in the film and ad business. Most recently it was used for a magazine shoot (featuring model/actress Lucy Liu and $100,000 in Yves Saint Laurent handbaggery) and for a commercial for Dell Computers.

The Clark Avenue field's big-screen work has included big roles in a couple of huge football flicks—*Semi Tough* and the remake of *The Longest Yard*. (It was not used, however, for the pigskin classic *North Dallas Forty*—the picturesque LB baseball yard Blair Field, home of the Wilson Bruins, the LB State Dirtbags and the Long Beach Armada—was remade as a football stadium for that one.)

Admakers have been spending time elsewhere in Long Beach in recent weeks. Commercials filmed recently in town, according to the city's special events office, which issues permits for Hollywood and Madison Avenue projects here, include:

—Honda Japan, at Heartwell Park.
—The Kia QM5 SUV on the beach at Granada Avenue.
—Mazda, at the Pike parking structure.
—Nissan, below Ocean on Cedar Walk.
—Allstate Insurance, at El Dorado Regional Park's archery range.

—July 15, 2008

MUST BE THE PALM TREES

For as long as we can remember, which is four years, there has always been a series that's pulled this burg's fat out of the fire in terms of popping for film permits.

These are series that return repeatedly to make use of their location managers' favorite settings in Long Beach.

You had your *Ally McBeal* hauling cameras almost weekly out to Third Street and Cedar Avenue to shoot in all directions, using the First Congregational Church, the Willmore Building and La Traviata restaurant.

No sooner did that show waste away to nothing than *Joan of Arcadia* set the Bluff Park area on fire with the title character's family "living" in a house in

that part of town. The crew even made use of our little newspaper's building back in the old days when we were on Pine.

Sometime not too long ago, Long Beach became noted for its uncanny resemblance to South Florida. It played Miami or thereabouts in a mess of movies, including *Bad Santa* and *Odd Couple II* (the latter of which you may recall as also going by the title *Odd Couple 2: Travelin' Light*, which didn't stick for too long, perhaps because the title made it sound a little fey, which it might've been. Who knows? Who saw it?).

Then *CSI: Miami*, the South Florida slice of the plenty-to-go-around *CSI* pie, made Long Beach home. Now, there's a new Miami-based series brewing: *Cane*, a drama based on the treasure and corruption in the sugarcane business. The show features Jimmy Smits and Rita Moreno.

The *Cane* crews have been in town on several occasions already, shooting ambient seashore shots at our Floridian-looking (when you soften the lens with Vaseline, get just the right angle and don't show the evil brown froth that gathers at the water's edge, waiting to evolve into something capable of launching a full and lethal attack on the very people who nuttily support the retention of the breakwater—the very breakwater that allows for the evolution of the Killer Froth of Death. Ironic, or what?) beaches.

And, says one of our few remaining sources, the *Cane* people will be back in town soon using other locations, including a loft at the Walker Building on Pine Avenue.

So, *Cane* will be our latest favorite-son series: Say hello to our little friend.

—August 31, 2007

LB House is at Home in Miami

As everyone knows, our column on location filming in Long Beach is widely read. Huge crowds meet the train at the station when this column is delivered to their town in the early morning hours. When we write in this column that people should go out and buy puppets and learn how to use them really well, puppets fly off the shelves at your local puppet shop.

So, we weren't surprised when, after we wrote about how Long Beach homeowners might want to have their houses considered by location managers to take on the role of a home in Miami for a Showtime series *Dexter*, sure enough, a Long Beach home was quickly chosen for the role.

A house in the 2300 block of San Anseline Avenue near the Los Altos Shopping Center will play the recurring role as the home of the girlfriend of the titular character. Dexter, played by *Six Feet Under* star Michael C. Hall, is a likable forensics expert for the Miami Metro Police Department. In his off hours, he's a serial killer who kills people "who need killin'."

Naturally, we assumed it was our column that led to the discovery of the San Anseline home.

"You wish," laughed location scout and our new ex-friend John Robinson, who says he was driving location managers from *Dexter* around the Los Altos and Plaza neighborhoods when they happened upon the house that best fit the bill.

The homeowners, Jules and Jennifer Bourgeois, backed him up in this little fairy tale.

"We never even saw your ad for the house," said Jennifer.

"Column. It wasn't an ad, it was a column," we said, our face clouding over. "It's readable by millions of people every day on the Internets. It's huge."

"Column, whatever. We didn't see it. The location managers just came up and knocked on the door," she said. "It was weird. My husband was home, and we were just sitting there and all of a sudden people want to use our house for filming.

"We thought it was a little strange. My husband is an engineer, so he was looking the deal over real carefully, and I went and Googled *Dexter* and Showtime on the Internet."

Odd, because if you Google "*Dexter*" and "Showtime" on the Internet, you find our column about Showtime looking for a house for *Dexter* in Long Beach—the thirty-second item out of 96,700. Huge. The one-hour crime thriller will, according to our former pal Robinson, use the Bourgeois house for exterior scenes several times over the twelve initial episodes of the one-hour drama. But changes had to be made.

The house, in real life, was rather staid beige and wasn't overly decorated with foliage. To make it more Miamian, crews tossed in some palm trees and other potted greenery, splashed a bit of key lime color to the house and, most strikingly, erected a decorative, flamingo-hued faux-cinderblock wall in front—the wall is actually made of Styrofoam for easy removal between shoots, which is fine with Jennifer because she isn't wild about it.

She is, however, happy with the experience as a whole, as are the Bourgeois children, Gabrielle, nine, and Christian, six, who are enjoying their new life as show-biz kids, however tangential. "We got to ride with the stars over to the crew's base camp to have lunch," said Jennifer.

"Everyone involved is just wonderful. The whole production is a very well-run machine."

The *Dexter* folk shot their initial scenes last week and earlier this week. "This morning they're taking things down," said Jennifer on Tuesday.

Although she's been told the family won't get much of a heads-up regarding crews returning for future scenes, she said they're expected to film again at the house later this month and off and on through October.

And each time, of course, more money for everyone involved in the project, from the homeowners to the location scouts.

We, according to everyone who got their stories straight, had nothing to do with it.

—June 14, 2006

FILMING TAKES A PIT STOP

One thing that's quiet in Long Beach during Grand Prix season is the filming business. From April 1 through April 12, there's a moratorium on filming—no lights, no camera, zero action—as the city's crack Special Events and Filming Bureau and affiliated police and fire folk are too busy with the race to monkey around with Hollywood.

Getting in under the wire, with a March 31 shoot, will be crews from CBS' *Criminal Minds*, which is using beach boy Fred Khammar's Kayak Cafe (last seen on the big screen as a Miami Beach bar in *Bad Santa*) on Alamitos Bay. The outdoor cafe is taking on a bit of a stretch—but just a bit—in playing a bayside Jamaica location.

Among the projects given a no-go for the race period is *Daybreak*, a TV pilot for ABC that could bring the sort of work to Long Beach that *Joan of Arcadia* once did and that *CSI: Miami* still does.

Though they won't be able to film as they had hoped during the moratorium, crews for the pilot, which stars Adam Baldwin as "Chad Shelton, grizzled police veteran," will at least be filming next Thursday and Friday inside and outside an apartment at 505 Broadway in the East Village.

The apartment, above a laundry at the northeast corner of Broadway and Linden Avenue, will play the role of home for the grizzled Shelton.

If *Daybreak* is picked up for a full run, look for the filmers to be returning frequently to shoot exteriors of the apartment (the interior will be duplicated at the studio) and, as long as they're in town, other Long Beach locations.

February was crazy busy in Long Beach for makers of everything from TV ads to feature films. Almost fifty (forty-nine, to be specific) permits were issued in town during February. Some of the bigger February projects included:

CSI: Miami—Crews were "all over the place," an umbrella term that takes in locations at Appian Way, Bay Shore Avenue, Naples Plaza and El Dorado Park.

Mind of Mencia—The Comedy Central show shot skit scenes on the Promenade, between Fourth and Fifth Streets.

NCIS—The *JAG*-like navy crime drama was in town twice last month to film at Poly High School.

Medium—The NBC paranormal crime-solver show used the Arco Tower and St. Mary Medical Center.

Windfall—The pilot, about a group of friends who win a few hundred million bucks in the lottery, dropped a mess of bogus moolah for a scene shot at Blair Field. The scene also included baseball Hall of Famer Dave Winfield.

Reno 911!—The latter-day Keystone-y kops shot scenes at the Long Beach Convention Center and the *Queen Mary*.

Las Vegas—James Caan and cast visited the Pike at Rainbow Harbor for scenes at V2O and at the Cave nightclub on the arcade below the Ocean Center Building.

Bones—The drama about solvers of old murders used (in a non-stretch performance) the morgue at St. Mary Medical Center for some nice ambience.

Nancy Drew—A feature film about the popular teen sleuth shot at various locations in the neighborhood of Atlantic Avenue and Fifteenth Street.

Freedom Writers—The next Hillary Swank award-winner, based on the book and experiences of Wilson High teacher Erin Gruwell and her class, continued to chew up local scenery, using a number of sites, including streets and alleys on Willow Street in West Long Beach and at Shoreline Park. The latter scene required a cast and crew of four hundred—a record for the month!

—*March 16, 2006*

PROTECTION DETAIL

If you're in the Secret Service, you are a little on edge a lot of the time, we're guessing. We would be.

If our sole job in this world was to make certain that nothing untoward befell the first lady, and then, say, a mammoth car crash occurred within what we considered to be the danger zone, we would toss a blanket over Michelle

Obama's head (this isn't getting us on some sort of list or anything like that, is it?) and hustle her out to the armored black Denali and speed out to the awaiting Marine One or Two and chopper her out to the safety of the flight deck of the USS *Eisenhower* waiting offshore lobbing shells at the coastline.

The Secret Service was, of course, in town for Michelle Obama's appearance at the Women's Conference on Tuesday. And, just as naturally, agents were here in advance making things nice and snug, and one of the things they didn't find overly nice and snug was a planned TV commercial for Liberty Mutual Insurance.

Crews and actors and stunt people for the filmers had planned a three-day shoot (bad choice of words, perhaps, in this case) involving the collision of a couple of cars at the intersection of First Street and Elm Avenue, just a couple of blocks from the conference and the Arena, where Mrs. Obama was scheduled to speak.

Car crash nearby? That's a negative, said the Secret Service.

Happy ending, though. This city is lousy with intersections at which a car collision would seem totally realistic. The Liberty Mutualists simply took their show down the road at a safer remove a couple of blocks north and a block east to the frequently filmed intersection of Linden Avenue and Third Street.

—*October 28, 2010*

KA-BOOMING INTO TOWN

It's great enough news that there's finally a new spin-off of the David Hasselhoff 1982–86 think piece *Knight Rider*. Throw in the fact that numerous scenes for the offshoot series have been filmed in and around Long Beach, and it makes us want to explode with the anticipation of viewing the new show *Team Knight Rider*, which debuts Saturday at 9:00 p.m. on KCOP/Channel 13.

We might as well explode, because everything else does on this—there's no better word than "explosive"—series.

For several weeks, working under the title *Time Traveller 2000*, the series' makers have been blowing up cars, trucks and boats in chases mostly around downtown Long Beach streets and in the waters off our shores.

The original *Knight Rider* had its share of blowups, with its can-do hero motoring around in a futuristic car that made James Bond's vehicles look like soapbox derby rejects. Not only does *Team Knight Rider* have better cars, it's got five of them, making the expression more-better particularly appropriate.

If you've got a pair of good binoculars, you can watch the *Team Knight Rider* folks in action on Tuesday, Wednesday and Thursday as they film boat chases and, naturally, explosions, in the waters off First Place in Long Beach.

More excitement in Long Beach comes today at the West Coast Hotel on Queensway Bay near the mighty *Queen Mary*. A crew from PM Entertainment will be using much of the hotel to film chasing and shooting scenes for the upcoming TV movie *L.A. Heat*.

A hotel representative said the crew will be using locations in the hotel's restaurant, lobby and conference areas.

The same company, filming west of town last weekend, closed the Terminal Island bridge for some industrial-area shots.

On a classier note, Robert Goulet—"Bob," to those of us in The Industry—appeared on Third Street and Pine Avenue on Saturday, in front of the stately Farmers & Merchants Bank, to film a TV commercial for Mercedes-Benz.

—October 6, 1997

TIME PIRATES

The *Queen Mary*, one of the greatest actor/boats in film/nautical history, goes into the way-back machine on an upcoming episode of ABC's Monday-night series *Timecop*.

Film crews were crawling all over our beloved craft from October 3 through 9 for an episode called "Lost Voyage." Set in July 1939, the *Queen* has a non-stretch role as a cruise ship that has gold bars hidden in the hold. Futuristic pirates with apparently the same ability as the timecops (who can zip in and out of the continuum, messing with history) go back to '39 to sink the ship so that they can, with 2007-era ship-salvaging capabilities, retrieve the treasure. Don't think about it too hard, or your head will pop.

Another Top 10 Long Beach location, Blair Field, has been featured in a lot of sports-related projects, but horseracing is something new to the veteran ball-yard. FOX's Sports West 2 cable channel had crews at Blair on Thursday to shoot promos for its Horsecam, a camera mounted, actually, on the jockey's head to give you that horse-eye view of coming around the clubhouse turn at full stride. FSW2 is currently using the equine equipment in its nightly (Wednesday–Sunday) coverage from Santa Anita's Oak Tree meet.

Whenever there's something a film or TV director doesn't know—which covers a breathtaking area—the director needs to hire the expertise of a technical adviser. If you happened to catch Wednesday's new ABC comedy *Dharma & Greg*, you might've been struck by the verisimilitude brought to a skydiving scene (or, actually, near-skydiving, since they never jumped) featuring Dharma's and Greg's fathers, testing one another's manhood.

The technical advisers for the shot were Lakewood leapers Tom and Elizabeth Keavney, who obtained the equipment for the actors and told the director how to make the shot look realistic.

"They shot the whole thing on a set," said Elizabeth. "They had a real Cessna airplane that was cut apart so you could shoot inside. The first thing we did was have them take the passenger seats out. In a jump plane, there's a pilot seat and the rest are removed to make room for more people and gear."

Then, the couple also told the crew to lose the clouds, generated by a smoke machine and blown past by huge fans to connote speed.

"They toned it down quite a bit," said Elizabeth, "but there was still too much. With that much cloudiness, the FAA wouldn't let you fly, and a pilot wouldn't let you jump."

—October 13, 1997

COMEDIAN TIM CONWAY "SPEEDS" AND BOUNCES ALL OVER LB

They shot the 1994 summer sizzler *Speed* in Long Beach, but they didn't shoot the upcoming summer sizzler sequel *Speed 2: Cruise Control* in Long Beach, but they're shooting *The Making of Speed 2* in Long Beach. Figure out Hollywood, and you'll be rich enough to hire Steven Spielberg as a houseboy.

The Making of Speed 2 will probably, as most "making" features are, be a collection of stars and crew chirping happily about what a thrill and crack-up it was working with one another on the project.

But *The Making of Speed 2* will also include a sendup of its subject, with a starring role by career spoofer Tim Conway and cameos by *Speed 2* (as well as the first *Speed* star) Sandra Bullock and director Jan De Bont.

Some of the first *Speed* movie featured the film's crazed runaway bus careening down Ocean Boulevard in Long Beach. For *The Making*, a crew was in town Thursday and Friday to shoot as the bus (which doesn't appear in the sequel) made an appearance, with Conway at the controls, rocketing into a boat landing area near Marine Stadium, behind Marina Pacifica.

The idea is that Conway is out to find the runaway Caribbean cruise liner of *Speed 2*, but in his usual bumbling way, he falls out of the bus. Then, he commandeers a Jet Ski and tears off up the waterway, before being flung from that vehicle as well after colliding with a buoy. Floundering in the water, Conway is rescued by Bullock, who pulls up in a high-power cigarette-hull boat.

Of course, Conway's jettisoned from that craft, as well, and, while bobbing in the ocean, he calls (via cellphone) for a seaplane to pick him up. In the closing scene, he's being hauled aboard the luxury liner (though not the ship from the movie) by Bullock and director De Bont, who also directed *Speed* as well as the similarly thrill-driven *Twister*.

—May 5, 1997

FLAMES OF FAME WILL LICK AT LB's OLD MASONIC TEMPLE

It'll be a blazing hot time in Long Beachollywood on Monday and Tuesday, at least at the old Masonic Temple on Locust Avenue near Eighth Street—a historic building that will, if all goes well, be set on fire by people who are good at this sort of thing.

The burn scene is for a Paramount TV pilot called *119*, a drama series about life at a fire station. So, if you're among the Long Beachers who will see smoke billowing from the building's windows on Monday or Tuesday, don't call 911, because they'll just tell you it's *119*.

Among those who'll be at the location will be Long Beach Fire Department Inspector Chris Tave, who's in charge of special events for the department. Tave explains how a film company manages to create the illusion of a building ablaze. Like any explanation of trickery, it's pretty disappointing; if you don't want more magic sucked out of your life, skip the next couple of paragraphs.

"The special-effects people use what's called a 'fire bar,'" explained Tave. "It's a tube anywhere from a couple of inches to a couple of feet in length that's hooked up to a five-gallon butane tank." Basically, it's the workings of a backyard gas barbecue, without the kettle, the grill or the burgers. "They just hold that up in front of the cameras, and it looks like something's on fire."

For the Monday and Tuesday shoots, the special-effects crew will have two to four flame bars working, but chances are, no one from outside the building will see any flames at all. What they will see, however, is plenty of smoke puffing out of windows on the temple's south side. Burning a special Hollywood brew of vegetable oils and solids, says Tave, creates the smoke.

As is always the case on any sort of filming in Long Beach, a fire inspector will be on the set; Tave isn't working on the days of the filming; he's just going to watch. A fire inspector will be on hand in an official capacity, as is always the case when Hollywood plays with matches in Long Beach.

"We go to make sure everything's going OK," says Tave. "With shots involving fire, you always have to watch out for directors, who always seem to be shouting to the guys controlling the flame bars, 'Bigger! Higher! Hotter!'"

—March 29, 1997

THE PYRAMID AND BLAIR FIELD

Judging from feature films and television shows and commercials, Long Beach is one of the nation's premiere athletic burgs. In just a couple weeks, local landmarks have been used for a number of sports shots.

Last week saw the St. Anthony High School gymnasium used for a basketball game in the feature film *Pleasantville*, starring Jeff Daniels and 1997 supporting actress and actor nominees Joan Allen and William H. Macy; and ex-Laker star and current team G.M. Jerry West showed up with his (temporarily) fallen star Shaquille O'Neal for the filming of a Reebok basketball shoe commercial at the Pyramid and at El Dorado Regional Park.

The Pyramid, in its short life, has already had an impressive career in showbiz. It's a natural: stunning good looks, an almost spooky ease when it comes to playing a gymnasium and plenty of parking for cast and crew. Recent roles for the pointy-headed location include a Taco Bell commercial, also featuring Shaq, and a setting in the sci-fi terror *Starship Troopers*, directed by Paul Verhoeven (*Total Recall, Basic Instinct*), in which the Pyramid was the site of a futuristic indoor football game. For that shot, filmed last August, locals were invited to show up as extras for the game. The film is scheduled to open November 7.

This week, the versatile sports site Blair Field is back in the spotlight on Wednesday for a filming of HBO's sports/comedy series *Arli$$*, which stars Robert Wuhl as a somewhat south-of-ethical sports agent. The shooting is closed to the public, and, as usual, there's no word on who'll show up for the taping, but the show has been graced by a number of famous jock-ular folk in cameos, including the ubiquitous (at least in today's column) Shaq O'Neal.

Of course, we could fill a column, and spill over into the want-ads, just listing Blair Field's appearances on the little and big screens, which have included everything from MTV's rock-n-jock softball games to Michael Jordan's *Space Jam*.

TV commercial-shooters continue to be enamored of Long Beach. On Thursday, UPS will be doing an ad aboard the *Queen Mary* in the Grand Ballroom, which will be closed to the public all day.

Also, Joe Jost's regulars will have to look for a temporary alternative watering hole on Wednesday, even though the beer will be flowing at the historic Long Beach tavern. The Anaheim Street landmark will be closed all day for the filming of a Killian's Irish Red beer commercial. Jost's is another longtime favorite of location scouts. It's got the old-time, everybody-knows-your-name look to it that you just can't coach. Jost's has been used for commercials for virtually every major brewery, as well as some boffo big-screen appearances, including a role in the Kevin Costner and Whitney Houston hit *The Bodyguard*.

"There'd be people filming in here every week if I let them," said Jost's owner Ken Buck, grandson of the original Joe Jost. "Art directors love the look of the place, and agents call me all the time, but our main business is being Joe Jost's. I'll maybe close it down four or five times a year, but that's about it. I have to keep our loyal customers happy."

—March 8, 1997

READERS RECALL

It was quiet on the set again this week—the only cameras rolling around Long Beach were on Wednesday as a crew was on Linden Avenue at First Street for a reshoot of a Honda commercial for Japanese TV.

So, while we're expecting some bigger news next week, we're living today on some responses to On Location from readers.

"I can recall several instances of the Vincent Thomas Bridge subbing for the Golden Gate on the old *Ironsides* series," writes reader Rick Mayberry, who grew up in Long Beach during the '50s and '60s and now lives in Oregon. "Also, shots of the old cemetery at Orange and Willow hosting the inevitable werewolf or vampire buffet. My favorite, however, remains the [then] new downtown civic center in Lincoln Park being used as the site for the massacre of the peace delegation in the pilot episode of *Battlestar Gallactica*.

HELD OVER!

SHOW STARTS AT DUSK
REGULAR PRICES!

GA 4-9931
LAKEWOOD
DRIVE-IN
CARSON at CHERRY
LONG BEACH

STANLEY KRAMER PRESENTS "IT'S A MAD, MAD, MAD, MAD WORLD"

IT'S THE BIGGEST ENTERTAINMENT EVER TO ROCK THE SCREEN WITH LAUGHTER!

ULTRA PANAVISION® AND **TECHNICOLOR®** RELEASED THRU **UNITED ARTISTS**

ACTION SCENES FILMED IN LONG BEACH!

PLUS — Comedy in Color "PERFECT FURLOUGH"

Theatergoers in Long Beach had the meta experience of watching *It's a Mad, Mad, Mad, Mad World* in the middle of the very town where much of the movie was filmed. *Courtesy of Press-Telegram.*

"Another memorable occasion was sitting in the old Rivoli Theater on Long Beach Boulevard and watching *It's a Mad, Mad, Mad, Mad World* on a screen that was showing scenes that were shot right outside of the theater!"

Long Beacher Lorenzo Gigliotti offers: "(Cable's) Speedvision channel has a regularly scheduled show called *Lost Drive-In* that features, as its logo, a shot of the decaying Los Altos Drive-In—the words 'Los Altos' morph into the word 'Lost.'"

"An aging Bruce Dern is the cranky host seated somewhere in the theater parking lot lamenting the loss of these American institutions and also reminiscing and commenting on (often making fun of) the films being aired on the program," reports Gigliotti. "The films are usually B or C fare, but they are featured because they often have really good footage of historic racing venues."

—February 22, 1997

WE'RE BIG IN ASIA, AND THE QUEEN OF THE SCREEN

One benefit of Long Beach's prime location on the Pacific Rim is the fact that for Asian countries wanting to shoot some film here, it's just a quick hop across the Pacific Pond to the ultra-photographical wonders of our city.

Long Beach is used frequently as a backdrop, especially in commercials, for Asian television. Last week, Samsung electronics shot a spot on Pacific Avenue downtown for use in a Korean TV ad, and on Tuesday, from 6:00 until 10:00 a.m., a Honda commercial will be taped at First Street and Elm Avenue for future airing on TV in Japan.

Now, if Japan ever manages to succeed in borrowing the *Queen Mary*, Long Beach will be missing not just a big ship and civic icon, but a pretty fair-sized Hollywood bit player as well.

Since 1968, when the *Queen* had been a Long Beach local for only a year, Tom Witherspoon and his son, Andy, have been in charge of handling the ship's use as a film setting, and the ship has a mighty impressive resume.

After serving as a setting for a few TV specials, including *The Petula Clark Special* on NBC and *The Buddy Ebsen* special on CBS, the boat hit the big time in 1971 as the featured doomed vessel in the adventure classic *The Poseidon Adventure*.

Since then, the *Queen Mary* has logged more feature-film camera time than the busiest Hollywood star. A short list includes work in *The Godfather II*, *The Execution of Private Slovick*, *W.C. and Me*, *The Lonely Guy*, *The Natural*, *Tucker*, *Barton Fink* and, most recently, *Escape from L.A.* and *Multiplicity*.

Throw in TV, and it's been all over the dial: *Harry O*, *The Rookies*, *Night Stalker*, *Murder, She Wrote*, *The Bionic Woman*, *Charlie's Angels*, *Quincy*, *CHiPs*, *The Love Boat*, *MacGuyver* and last season's finale of *Beverly Hills 90210*.

Commercials? Sooner or later, they all come to the *Queen* to shoot an ad—from Coke to Depends, McDonald's to Merit cigarettes.

The *Queen* does all right financially for herself and her (current) homeport. To film there, production companies pay $4,000 per day for use of the ship, plus the $600 film permit fee that's paid to Long Beach.

Next up at the *Queen Mary* will be a Hallmark Hall of Fame production called *Crasher*, which is scheduled to be filmed February 25–27, and will include several scenes, including shots in the parking lot, on the ship's sundeck and bow and an action stunt scene in which a couple of people leap from the ship's deck into the moat.

—February 8, 1997

The *Queen Mary* and its attendant Dome have been used for scores of films in Long Beach—and the *Queen*'s career in films goes back to its days as an elegant ocean liner. *Hannah Grobaty.*

TRAFFIC ON THE SET

Back in the olden days of highly leaded gasoline, we used to be able to drive for miles here in Long Beach unchecked by traffic lights and stop signs. You could tear down Studebaker Road, from Anaheim Road to Second Street, nonstop, at fifty-five miles per hour. Or down PCH from Seventh to the Shore.

Nowadays? Forget it. The city seems to add a stoplight or a stop sign each day along our roads. Why even bother with speed limits? You can't get your car going much faster than twenty-five before you have to stop again.

But we'd never seen it so bad as earlier this week on Snake Road. It's ridiculous. Every ten feet—literally—they'd posted stop signs or traffic lights, snarling traffic and causing cars that weren't using the correct motor oil to seize up and die.

Those vehicles with Pennzoil motor oil, though, had no problem.

Pennzoil was in town on Thursday and Friday filming a TV commercial on the little known one-laner known to park workers as Snake Road not so much because it's riddled with adders, but because it snakes through a cozy, tree-lined section of El Dorado Regional Park.

The ad's gimmick is to show how much stop-and-go traffic there is these days, and the ad makers have gone way overboard to depict the extent of it.

In about a one-hundred-yard stretch, just off the eastbound Spring Street entrance, film crews have installed six stop signs and five traffic lights (mostly, maddeningly, on red). It's an exaggeration, of course—so far.

The Pennzoil shoot is just another walk in the park for El Dorado, which has seen plenty of action, thanks to its natural good looks. Among its feature film credits are Albert Brooks' *Defending Your Life*, Kevin Costner's *Tin Cup* and Oliver Stone's *Nixon*. The park's last TV commercial was for Keystone beer, in which the park played a nonstretch role as a site for a company picnic—albeit, one where beer-drinking is permitted, unlike El Dorado.

El Do is also a popular location for still photography for catalogs and print ads. Lexus and Mercedes-Benz were two recent shooters using the park's roads with the lakes providing an out-in-the country backdrop.

—January 25, 1997

RATED P FOR WEIRD

It's Weird-NBC-Shows-that- Begin-With-a-P Week here in Long Beach, just steps from our sumptuous suite of offices high above Pine Avenue.

Today, the weird NBC show *Profiler* will be shooting scenes at the oft-camera'd locations of La Traviata restaurant at the historic Willmore Hotel on First Street and Cedar Avenue, plus the similarly frequently shot First Congregational Church, right across First Street from the Willmore.

Profiler, if you haven't seen it, stars Ally Walker as a forensic scientist who—and if she has this talent, why even go to forensic-science school?—can visualize murders through the eyes of both killers and victims.

La Traviata has recently been seen on the popular and only sorta weird *Ally McBeal* show on Fox, as well as the made-for-TV movie *Cab to Canada*.

The toothsome First Congregational has also been used several times this year, for a couple of episodes of *Ally McBeal* and also for the weirdly titled feature film *Dancing About Architecture*, which will star Sean Connery (who wasn't at the church for the filming) and *X-Files* star Gillian Anderson (who was).

"We have a lot of location scouts who check us out," said church janitor and Person-Who-Works-With -Filmers Jill Mitchell. "They always say they like our sanctuary, but it holds so many people—about 1,500—that they can't afford to fill it up with extras," she said. "But they love our smaller rooms that are all tucked out of the way like catacombs."

Profiler, in particular, seems like a show given to catacombs.

Then, on Wednesday, the weird NBC show *The Pretender* returns to the streets of Long Beach, where crews for the program (which, like *Profiler*, airs Saturday nights) will be shooting scenes at Long Beach's Cooper Arms on Linden Avenue and Ocean Boulevard in LB's emerging East Village.

The Pretender is even more *X-Files*ian than *Profiler*, with its main character, Jarod Russell (Michael T. Weiss), being a guy who was taken from his parents and trained to be a Supermind at the mysterious "Centre," from which he escapes and goes around assuming all manner of identities feeling other people's pain.

—November 10, 1998

BIG LENS ON CAMPUS

When Hollywood wants to go to school, it frequently comes to Long Beach, where campuses can take on just about any look a set designer could want, from the classic old-timey gymnasium at downtown's St. Anthony High School to the twenty-first-century look of Cabrillo High on the Westside.

Show-bizzers making themselves at home at school is, at first glance, nothing but a good deal for educators: There's money, there's prestige, there's recognition, but there's also a down side of sorts. How best to put this without sounding rude?

Let's let Long Beach Poly co-principal Shawn Ashley handle it for us: "It's like having relatives come and stay for a while," he says. "It's nice that they come, but you're not particularly sorry when they leave."

The latest gaggle of relatives to visit Ashley and Poly was the cast/crew of *Coach Carter*, who visited Poly for more than two weeks in January. Actor Samuel L. Jackson was on campus for much of that time shooting school scenes for the real-life story, in which Jackson plays the title role, about a high-school basketball coach who benches his championship-bound team for disciplinary reasons.

The whole entourage then moved to St. Anthony High for almost two months—crews were still tearing down the set on Friday—to make use of that school's frequently filmed gymnasium.

"We've never had anything quite like this," says Gina Rushing, president of St. Anthony High School. "They were here more than fifty days and that had an impact not only on the school, but on the parish in terms of parking and other inconveniences. I'm not sure we'd do anything this long again. We'd really have to look at the logistics and the planning."

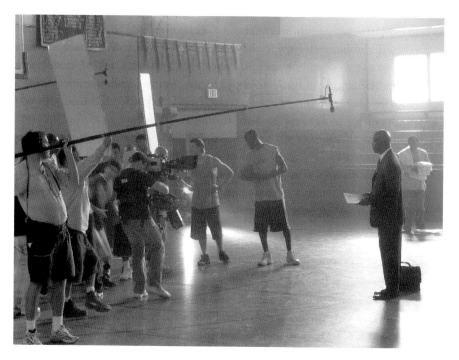

Samuel Jackson spent a lot of time in school in Long Beach for his role as *Coach Carter*. He filmed scenes at Poly High, and he's shown here working in the St. Anthony High School gymnasium. *John Robinson/Long Beach Locations.*

Still, Rushing says, the filming of *Coach Carter* was "a huge benefit for the school and the parish, both financially and also in terms of the excitement of filming and the pride in our facilities."

While some of the filming took place in the locker rooms at St. Anthony, the crews used the gym for most of the filming—which necessitated moving the boys' basketball team to other gyms for much of its regular season, plus its surprising appearance in the playoffs.

Rushing says she didn't know the gym would be tied up by filmers. "It wasn't detailed in the contract, and it won't happen again," she says.

Regarding the film's star, Rushing says, "He was great."

How great was Jackson? "Well, he wasn't extraordinarily approachable, but he wasn't rude or anything like that. We invited him to speak at graduation, but we haven't heard back from him."

TIGER, TOO

Filming is a fairly regular sight at Poly. Tiger Woods was there recently to film a public-service spot, and co-principal Ashley can rattle off the feature film titles that have made use of the venerable Long Beach campus.

"Let's see, *The Craft* used the pool, we had two *American Pies*, *The Other Sister*, *The Insider* with Russell Crowe…"

And, of course, Samuel L. Jackson and *Coach Carter*. How great was Jackson?

"He wasn't so great with the kids," recalls Ashley. "He rode around in his golf cart from his trailer to the set. Kids would yell, 'Hey! Mr. Jackson!' but he wouldn't even make eye contact. It was kind of sad."

Surely Tiger Woods was good with the kids?

"No, he was about the same."

Ashley, and most people whose job descriptions include balancing business-as-usual with the unusual business of show, is primarily interested in maintaining the former; the latter is a luxury.

"They want to shoot a movie, and I'm trying to educate. They want to use a classroom, or they want to 'borrow' some students as extras. No. That's not going to happen. You can use classrooms that are vacant, you can come after 2:40 when school lets out, you can come on weekends or in the summer, but you are not going to disrupt the students."

DISCOVERING CABRILLO

Over at the campus of Cabrillo High, principal Mel Collins says the same thing—in fact, the former Poly principal and longtime friend of Poly's current boss laughs, "Everything Shawn Ashley knows, he learned from me."

Already in demand because of its new looks, Cabrillo was visited most recently for about a month by the cast and crew of *Dodgeball: A True Underdog Story*.

"Location scouts call and if I feel their intent is good and they have a solid reputation, well, then, come on out and we'll go from there," says Collins. "But it's never, ever going to be at the expense of the kids."

Like Ashley, Collins isn't over-awed by Hollywood. "Not once did I go in and watch them shoot because I wasn't the least bit interested," says Collins. "Some of the kids get excited at first. Some of them wanted to be extras on the weekend—you get to work all day for $15, a box lunch and a pat on the back. You want me to do that? You must be outta your damn mind!" he laughs.

"One thing they do very well is lunch and dinner. I'll go over there for that. Cold pizza in the caf when you can sit down to steak and vegetables and iced tea. Just the idea of sitting down is enough to appeal to me."

—*March 29, 2004*

OUR BUILDING FINDS WORK

Most days when we bother to show up to work we come in the front door attended by great fanfare. Rose petals are tossed gently in our path, offerings of rare spices and bolts of fine fabric from the East are presented, our secretary rustles us up some grub, etc. It's all there in the contract.

On Tuesday, we have to come in the back door off a squalid alley like some sort of servant or something. The whole thing leaves a lousy taste in our mouth.

Hollywood is the reason for our being so horribly inconvenienced (for which we should be handsomely compensated, our attorneys shall argue). On Tuesday, the stately *Press-Telegram* building on Sixth and Pine will be transformed into the *Arcadia Herald* for the filming of the popular *Joan of Arcadia*, which airs Friday nights at eight.

Also, John Travolta, a local on-location vet (you'll recall his stunning work at our actual desk in the 1985 classic *Perfect* and his turn at the now-defunct Foothill Club in the epic *Lucky Numbers*), was back in town Monday with sidekick Danny DeVito. The actors were filmed on the Convention Center steps for the movie *Be Cool*, a sequel to their great (and we're not being sarcastic for once in our life) *Get Shorty*.

—*February 25, 2004*

MIAMI FOR *THE O.C.*

Well. Look who comes crawling to Long Beach. The "hit" Fox weirdcom, *The O.C.* Filmers and talent for the semi-soapy Newport Beach–based show were at the Surf Motel on Ocean Boulevard at Cherry Avenue all day Tuesday.

The colorful (blue) motel is, for at least the second time in its life, playing a motel in Miami Beach. Prior to yesterdays *The O.C.* performance, the Surf played a Miami motel in the 2001 feature film *Blow*, with John Depp.

In other Long Beach/Hollywood news, God may be able to speak to Joan of Arcadia, but Joan of Arcadia can't speak to God. At least she couldn't Tuesday morning when Amber Tamblyn, the "Joan" of *Joan of Arcadia* was in town to shoot some scenes at the Library Coffee House, St. Anthony High School and a parking lot near the corner of Third Street and Chestnut Avenue.

Tamblyn, however, came down with a case of laryngitis, so all of the scenes, save for the Library's, which didn't involve the title player, have been postponed until Tuesday through Thursday next week.

Is that all there is? You must be insane. This town is loaded with lights and cameras. Poly High School has been making a career out of playing Richmond High School, a real-life Bay Area high school, for the feature film, *Coach Carter*, starring Samuel L. Jackson.

Poly was tarted up a bit for the role, with crews spray-painting graffiti on the walls to give it that edgy urban look that was all the rage back in '99. The vandalian scrawlings were sprayed on walls treated with special peel-off paint, so when Hollywood abandons Poly next week, the school will revert to its original luster.

Finally, if you want to see a bit of Long Beach on the big screen this weekend, swing by your local flickery for Friday's opening of *Win a Date With Tad Hamilton!* and watch for scenes at a cozy neighborhood tavern called The Little Dickens. That would be, in reality, the granddaddy of Big Town's beer bars, Joe Jost's, which has appeared in more films than Mary Pickford and has held up, well, a lot better over the years.

—January 22, 2004

BIG NOISE IN BIG TOWN

There are jobs in showbiz that are a lot more fun than being a movie star, and right up there near the top would be the job of Pyro Guy for the CBS series *Criminal Minds*.

Crews from that show were in Long Beach last week and on Monday blowing things sky-high. Give us a barrel of gunpowder, a tanker truck full of highly flammable rubber cement, a car nobody wants and a Bic lighter and we will quickly forget all our dreams of being a lantern-jawed leading man in a flash.

Last Wednesday, the *Criminal Minds* blower-uppers created a nice ball of flames at a gas station on Atlantic Avenue and Fourth Street. Then, on Monday, they hustled over to downtown Long Beach's First Congregational Church parking lot to blow a car to kingdom come.

Sweet.

ELVIS (AND ELVES) SIGHTING!

In the off chance you're like us, or at least like us to the extent that you have just been too busy to watch any episodes of the NBC series *Las Vegas* yet, then you wouldn't know that the Seaside Way entry to the Terrace Theater regularly plays the role of the front of the Montecito Hotel & Casino of *Las Vegas*.

In recent columns, we have already made the joyful proclamation that Christmas is, basically, here now, and crews from *Las Vegas* were in town Wednesday through Friday adding special, though woefully temporary, Yule ambience to Long Beach, filming their show's Christmas episode at that Terrace entryway.

We weren't able to swipe an advance copy of the teleplay, but the front of the Terrace, an area much used for car commercials as well, was decorated with a flock of flocked Christmas trees, plus, we understand, a cavorting Elvis and a herd of elves. By the time we got there, crews had already wrangled up the elves and Elvis and were busy rounding up the once festive, now forlorn trees.

And what would a Christmas episode be without a trip to church? To cover that angle, crews from *Las Vegas* went a few blocks over to the northwest on Thursday to catch some scenes at Hollywood's favorite holy house, the First Congregational Church.

KEEP 'EM ROLLING

Oh, and there's been so much more film action in town. Scenes were filmed last week for the CBS math/crime series *NUMB3RS*. Crews for that ranged from Mick & Mac's (formerly Hamburger Mary's) at 750 East Broadway all the way to the Port of Long Beach, where they shot some stuff at a generating station.

The Showtime series *Dexter* had crews swinging by their little stretch of Los Altos–turned–Miami last week to film some exteriors of homes on San Anseline Avenue as well as a scene at the SeaPort Marina Hotel (where Elvis stayed! A long time ago, when it was the Edgewater).

And *CSI: Miami*, whose crews never really leave Long Beach, were at the Long Beach Airport Monday shooting a scene in which a car is smuggled out of town (the town being Miami) aboard a big cargo plane, which was flown in by a private owner from Kingman, Arizona, after Boeing reportedly declined to let the filmmakers borrow one of its C-17s for the day.

Smith crews continue to commute on a fairly regular basis between Hollywood and their local hangout, shooting scenes at the *Smith* house on the Peninsula.

—*August 8, 2006*

Long Beach's Reel-ality

So far it's been a pretty tough week for a simple Long Beach boy to keep a firm grip on reality. It's difficult enough for us on most days, but this week it seems there's been a larger Hollywood presence than usual, definitely more than is normal.

For one thing, it's always weird to show up for a day at the plant here at the Arco Towers on Tuesday and find that it's been transformed, as it seems to be every other week these days, into a cop shop for the surprise Fox TV hit *Prison Break*.

We're lazy, but we are not police, so we don't much cotton to having to take the ridge route into work to bypass the grips and the best boys and the miles of dolly tracks and assistant directors or whatever they call those people who have ponytails hanging out of the back of their ball caps, all working as one crack squad to maintain the illusion that this isn't the building that we call home at all. No. It's a gigantic, shiny police station. How's that supposed to help us stay grounded in the real world?

The *Prison Break*-ers were down the street on Monday, at the Westin Hotel, which sports the grandest women's bathroom in all the land that is Long Beach.

A few days ago, we heard that *Prison Break* location scouts were looking around Long Beach for a women's bathroom commodious enough to use for a murder scene—big enough, that is, for a fake dead body plus all the gear required to film it—and the Westin, well, there's your place. Something to keep in mind.

About as far removed from reality as it's possible to get was what was going on Tuesday at rooftops of the various buildings that make up the landmark Lafayette in the East Village, and that was a promo trailer for what could turn into a pilot for what could become a TV series based on Clive Cussler's series of books called *The Oregon Files*.

A lot of work went into the bit of rosy-cheeked optimistic filming, including an impressive (that is, we wouldn't try it) leap by a stuntman from one Lafayette roof down to another. They'll never catch him—or at least we didn't see anyone jump after him.

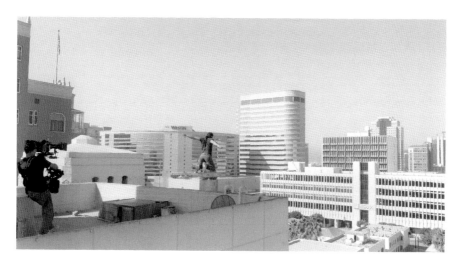

A stuntman leaps from the roof of the Lafayette in Long Beach's East Village for a scene for a trailer for the pilot of Clive Cussler's *The Oregon Files* TV series. *Thomas Wasper.*

Also—now we're back to Monday—filmers of the horrifying and intensely dark-humor plastic surgery drama *Nip/Tuck* were on the 600 block of Terraine Avenue shooting exteriors of a home, inside which we don't even want to know what was supposed to be going on.

Even your local doughnut or beer place—boing! memo to self: open a doughnut AND beer place—fell to the fantasy world of film on Monday.

The Colonial Bakery, at 355 Pacific Avenue, was given over to crews from *Dexter*, while Joe Jost's, at 2803 East Anaheim Street, like we have to tell you that, had locals crying in their nonexistent beers as the place was closed all day for the filming of an ad for Miller Beer. The commercial reportedly features actor Michael Chiklis, of the tragically defunct series *The Commish*.

—*August 1, 2008*

THIS JUST IN

The return of *Arrested Development*, filming now for a season on Netflix, saw crews and talent at Pine Avenue Pier at Rainbow Harbor two weeks ago. And *Dexter* is filming its seventh-season finale tonight at the Kayak Kafe at Alamitos Bay. Stay tuned for more...

—*October 5, 2012*

ABOUT THE AUTHOR

Tim Grobaty, a Long Beach native and resident, has been a reporter and columnist for the *Long Beach Press-Telegram* for more than thirty years. He has won numerous awards, including Best Columnist in the Western States in the Best in the West journalism competition in 2009. He is a recipient of the Long Beach Heritage Award for his columns about the city's history, many of which are included in his previous book for The History Press, *Long Beach Chronicles*. He is an inductee in the Long Beach City College Hall of Fame. Tim lives in Long Beach with his wife, Jane, and children, Raymond and Hannah.

Visit us at
www.historypress.net